Tara Ellis

Photography

-Nature's Tapestry

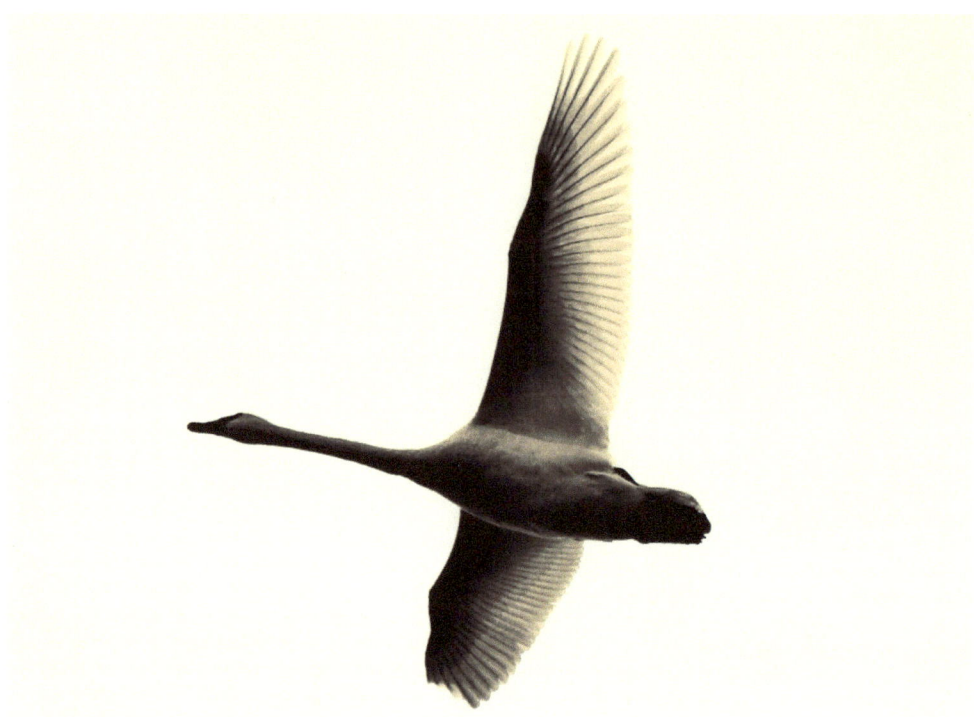

Copyright © 2014 Tara Ellis

All rights reserved. No part of this book may be reproduced, stored in a retrieval system, or transmitted by any means without the written permission of the author.

All images are the sole property of the author.

ISBN: **1494417677**
ISBN-13: **978-1494417673**

You can follow Tara on Facebook at taraellisphotography

Other titles by Tara Ellis:

<u>Young adult</u>

The Forgotten Origins Trilogy

 Bloodline

 Heritage

 Descent

<u>Middle-school</u> (9-12 yr reading level)

The Samantha Wolf Mystery Series

 The Mystery of Hollow Inn

 The Secret Of Camp Whispering Pines

All titles are available on Amazon. Find them at Tara's author page.

TARA ELLIS

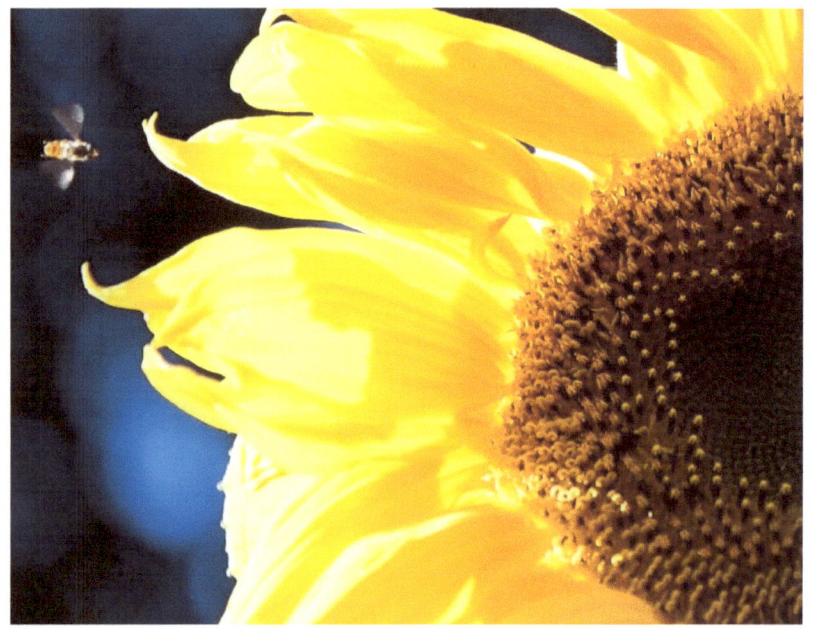

Table of Contents

Mount Rainier National Park

Woodlands

Valleys

Ocean Scenes

Lakes

Wildlife

Flowers

Silhouette

Sky

Inspirational

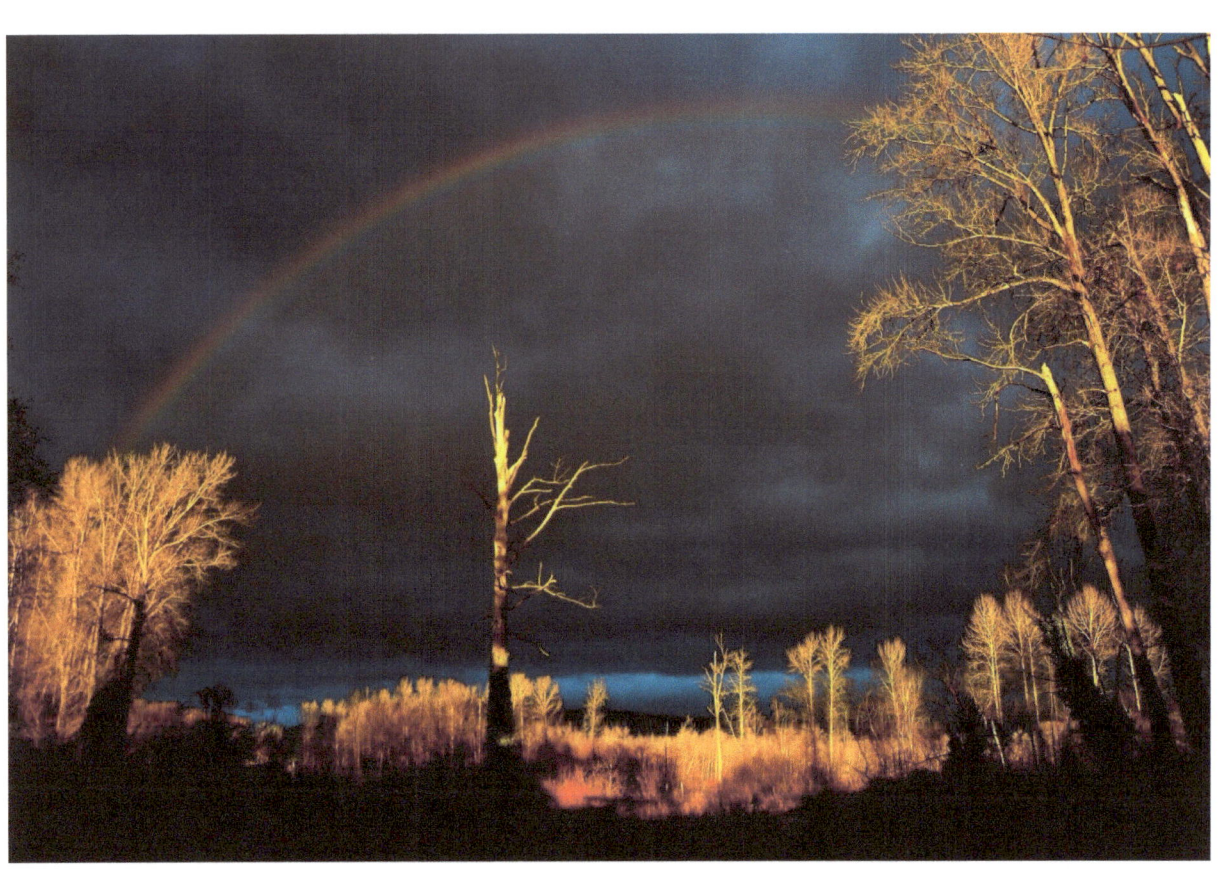

Preface

"Every part of this earth is sacred to my people. Every shining pine needle, every sandy shore, every mist in the dark woods, every clearing, and every humming insect is holy in the memory and experience of my people. The sap which courses through the trees carries the memories of the red man…" – Chief Sealth (Seattle)

I believe that if we all held this same belief, the world would be a different place. Nature has always spoken to me in a kind voice and it is through my photography that I try to share its story.

In these digital images, my goal is for the viewer to see them as I did when standing there. There is no trick lighting or Photoshop, no hidden agenda; just nature at its finest. It's important to me to capture the vividness and life of the scene or sometimes the smaller details of something we would never consider to stop and stare at.

So come along with me on a journey in pictures, as I take you through some of the gorgeous mountains and countryside of Washington, Oregon and Montana

The majority of these photos were taken with a Nikon D7000

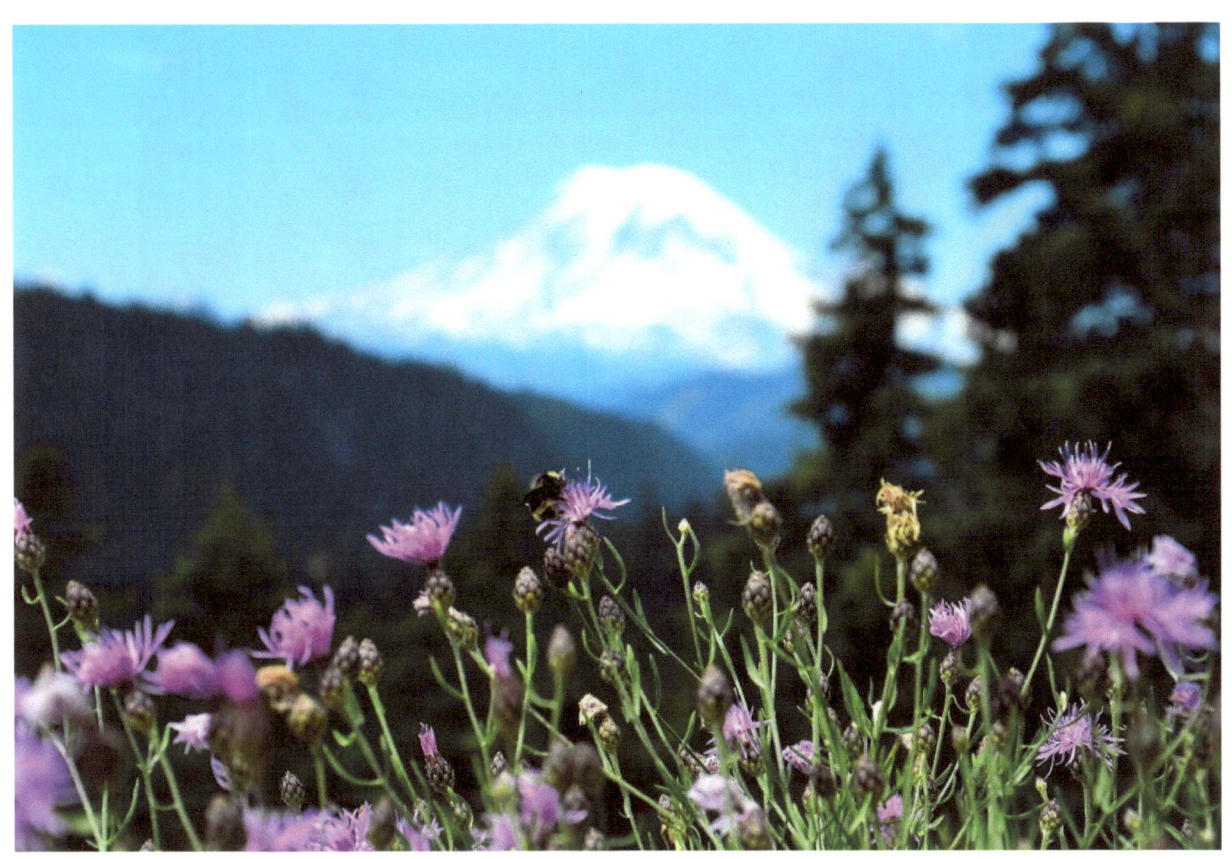

Mount Rainier National Park

I have lived in Washington State for nearly forty years, and I am embarrassed to say that last year, in 2013, was the first time I ever went camping inside Mount Rainier National Park. I've been there before and have seen the mountain hundreds of times, but I was missing out on the experience of the park. It is hard to describe, so I hope that these images tell a better story. The park was established in March of 1899 and was the fifth National Park in the United States. It includes 236,831 acres of amazing mountain terrain and near the middle of this attraction is the most dangerous stratavolcano in the country; Mount Rainier. It rises to over 14,000 ft and *is* an active volcano.

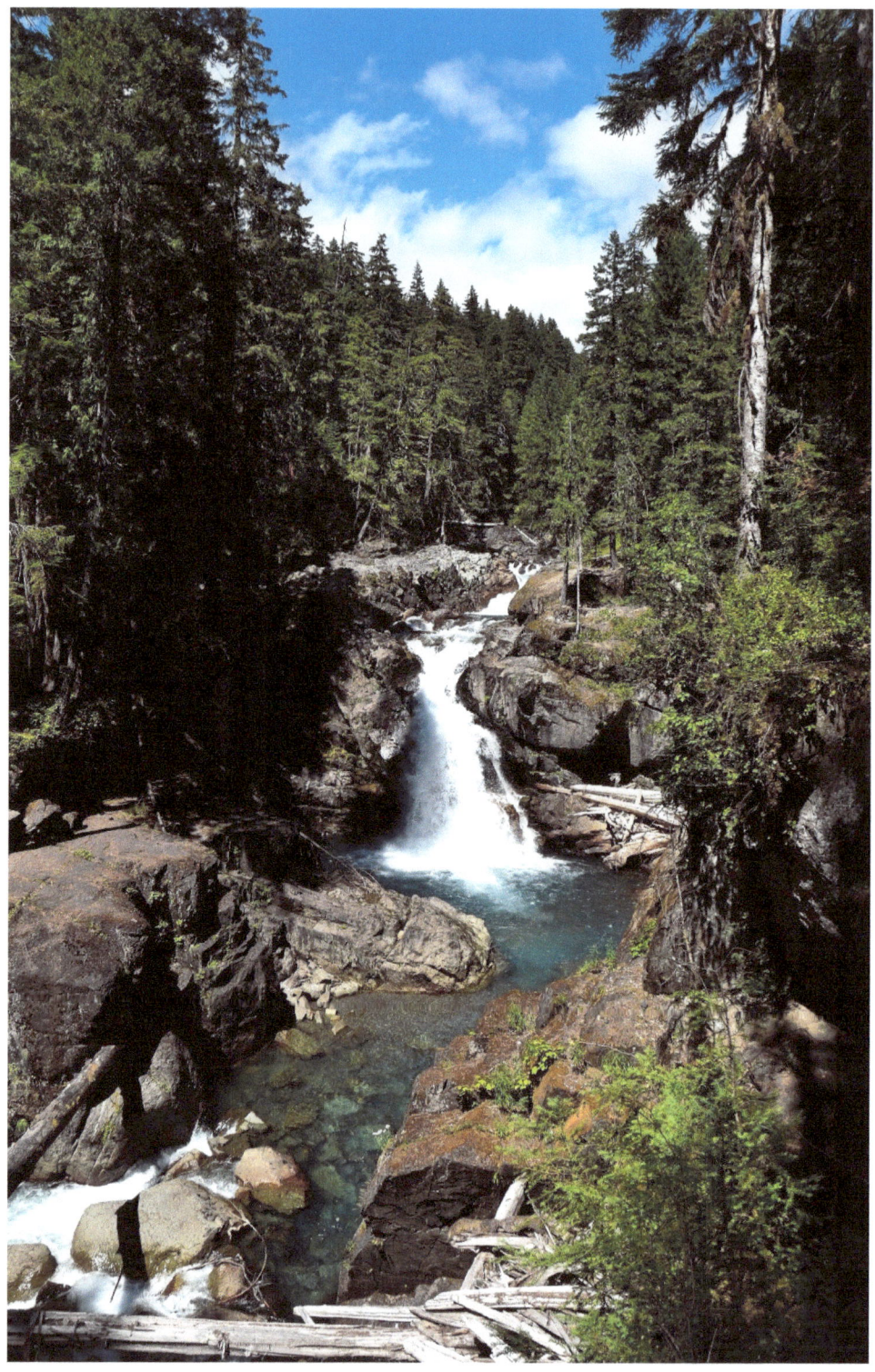

Silver Falls is a magnificent waterfall located on a 3 mile loop trail in Mount Rainier National Park. It is well worth the hike!

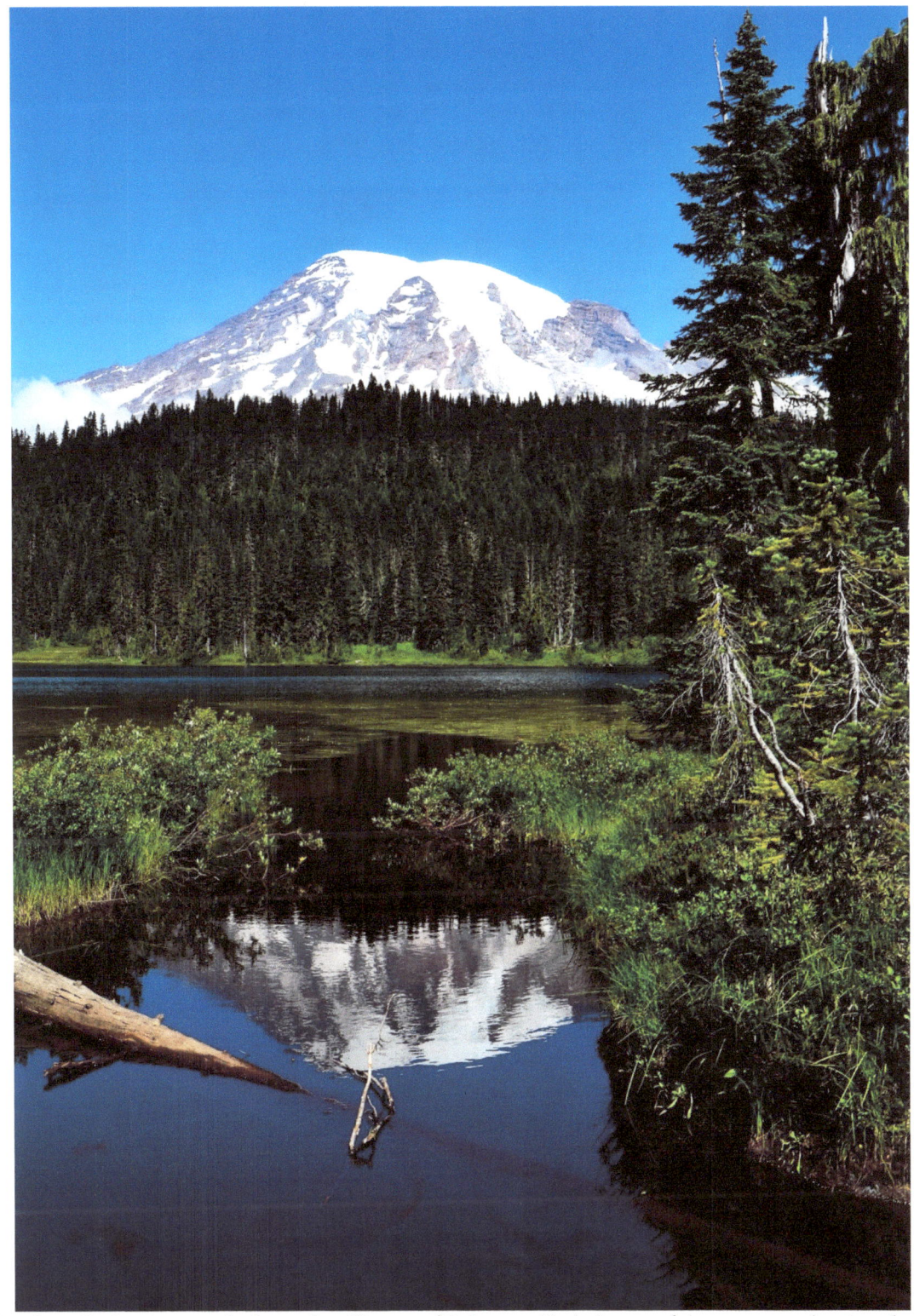

Reflection Lake is nestled at the Base of Mount Rainier and its namesake is obvious. The view is breathtaking and it was hard to leave.

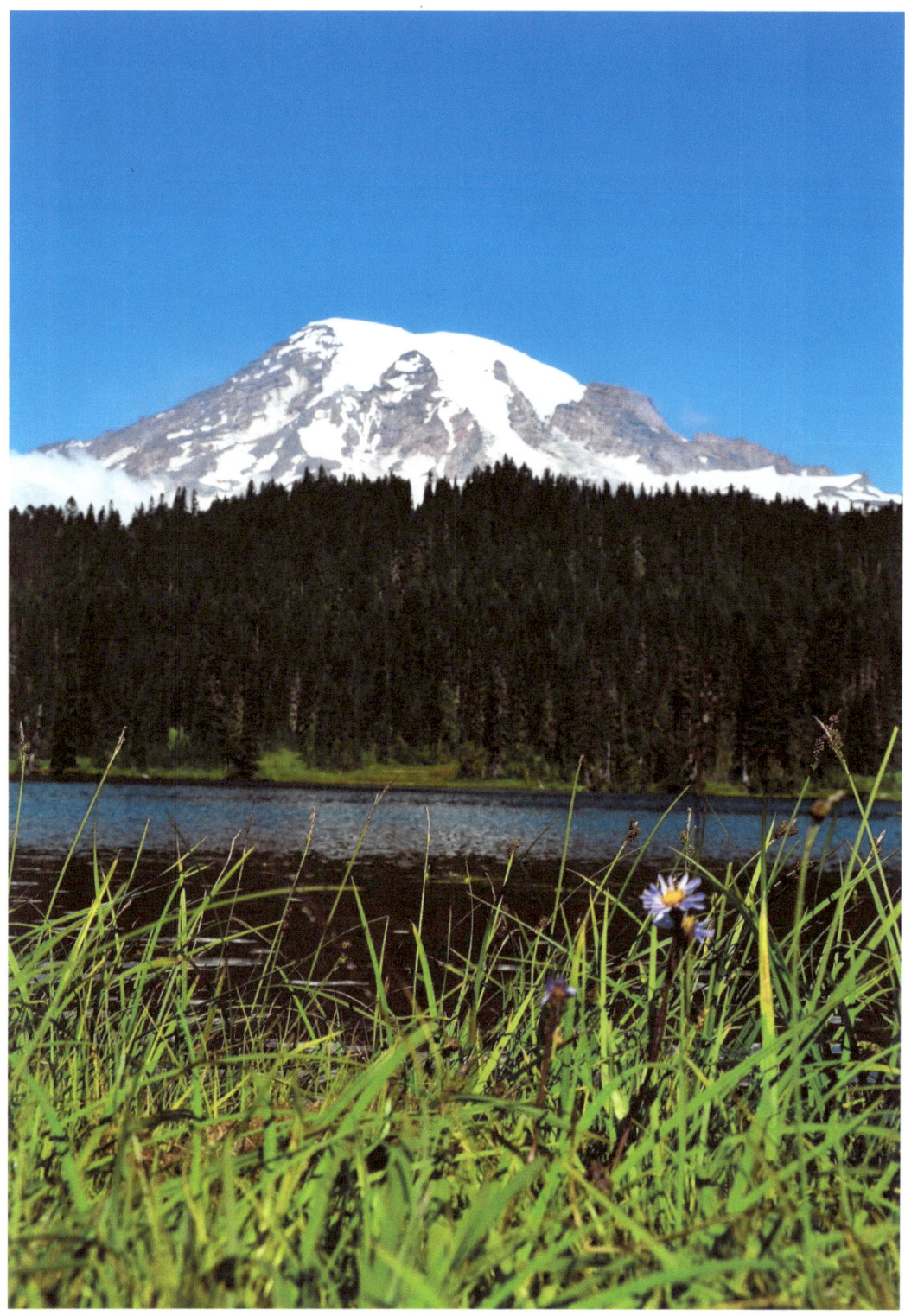

The meadows surrounding the lake are often full of flowers, even in late summer, when this photo was taken in September of 2013.

Another view

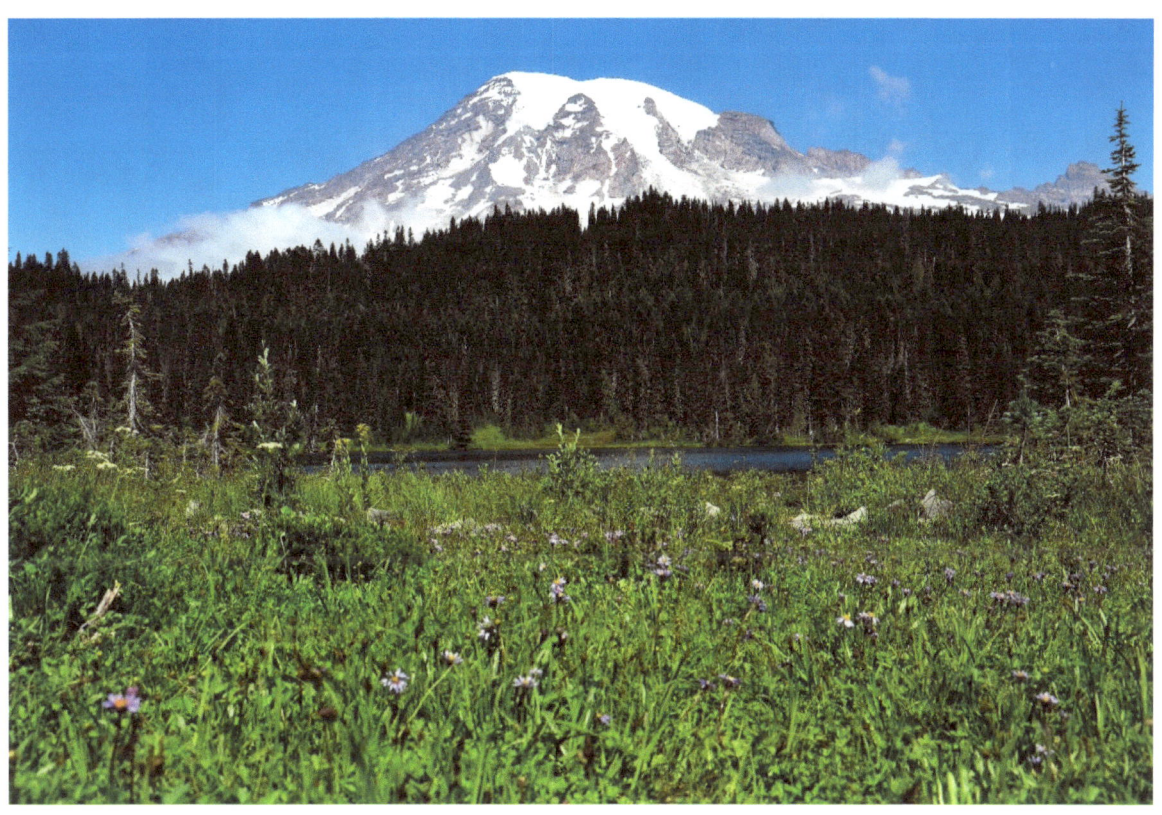

The Road to Paradise

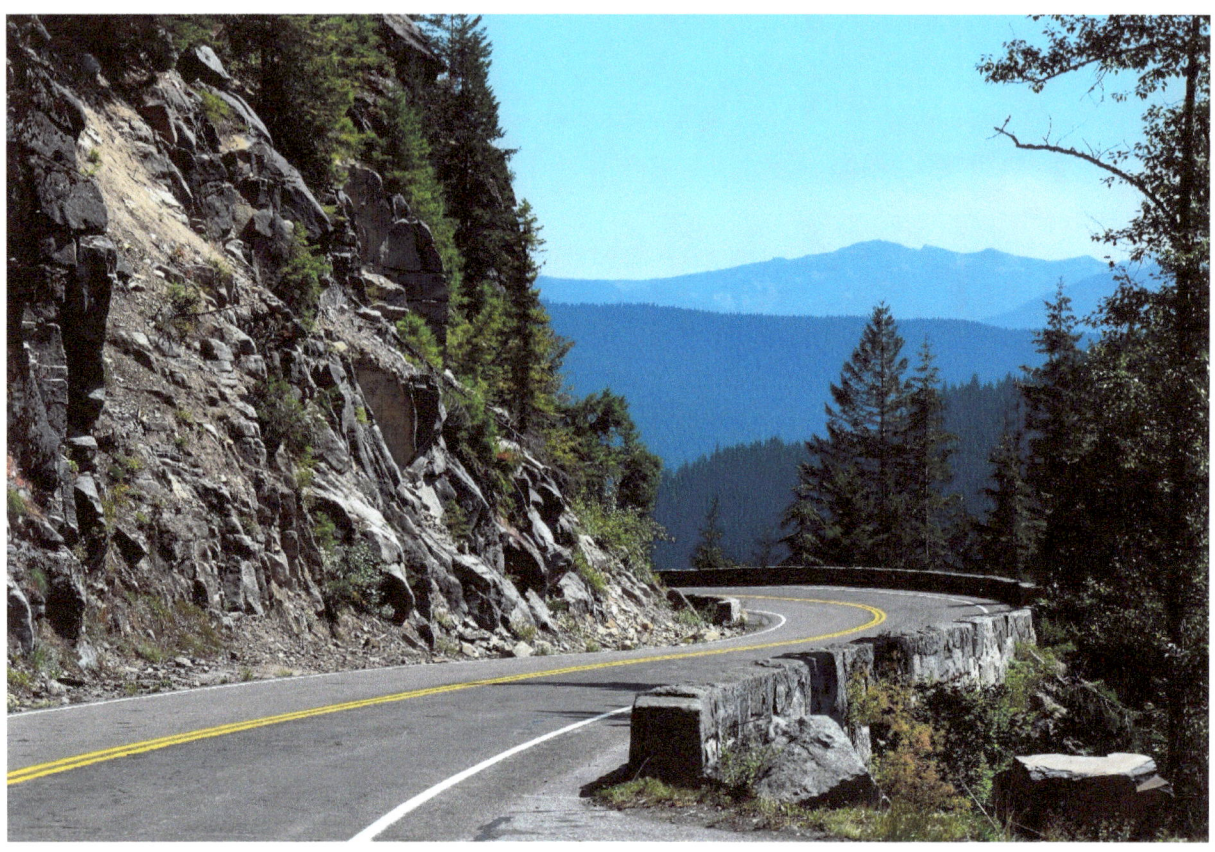

This is called the Road to Paradise because it traverses the park and eventually takes you to Paradise; a summit of sorts with a gift shop, restaurant and hotel, etc. The recreation area is used as a base camp for hikers that are trying to summit Mount Rainier.

I have included a picture of this road because it is a bit of a legend in Washington and also because it scared me to death. If you are not a fan of high roads with cliffs and no barricades, then this is NOT the road for you! If you can handle the heights, you get to enjoy scenery that is hard to compare. Not only are there views of Mount Rainier, but also Mount Saint Helens, framed by thousand-foot-deep valleys.

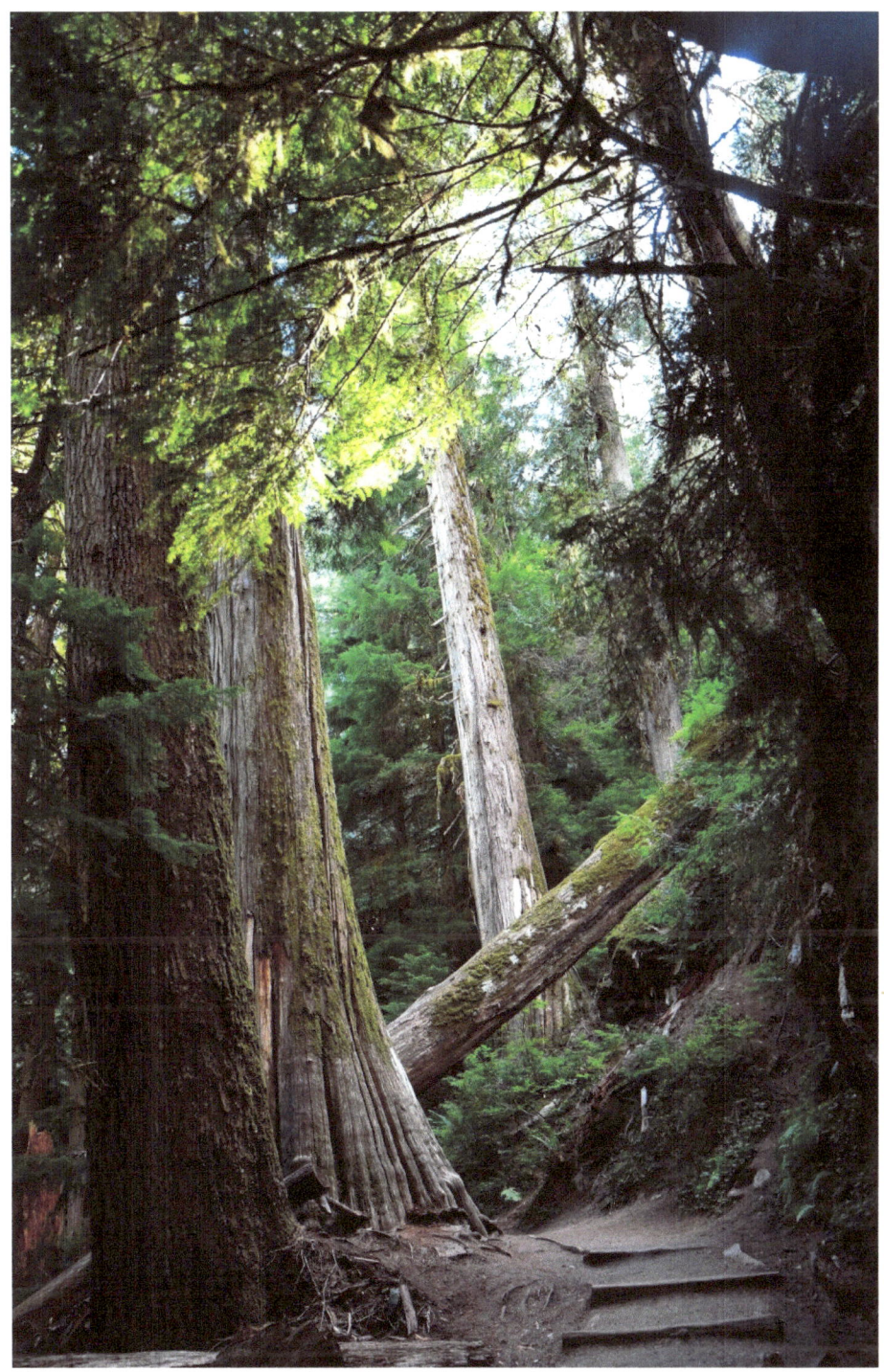

Just inside the entrance to the park in the Ohanapecosh campground area, is a small, one mile loop trail that takes you through an old growth grove of cedars called 'The Grove of the Patriarchs'. It truly is like walking into a chapel, but only one created by nature instead of man.

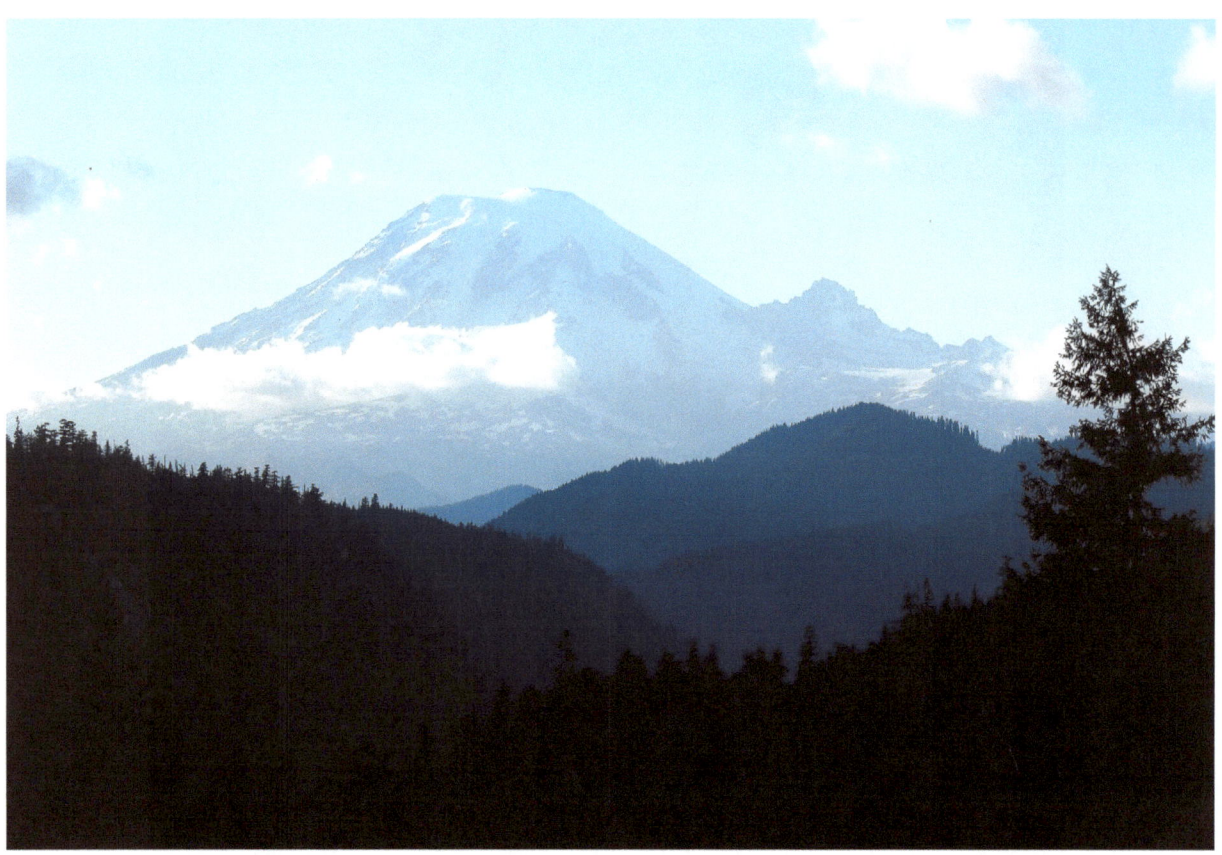

Finally, we come to the exit. As you are leaving on US Hwy 12 East, just outside of the small quaint town of Packwood; there is a lookout. I could spend hours here. You know the phrase; "Purple mountains majesty"? That echoed through my mind as I stood gazing at the rolling hills at the base of this live, dangerous volcano. One that thousands choose to live by in spite of the threat. I understand why.

.

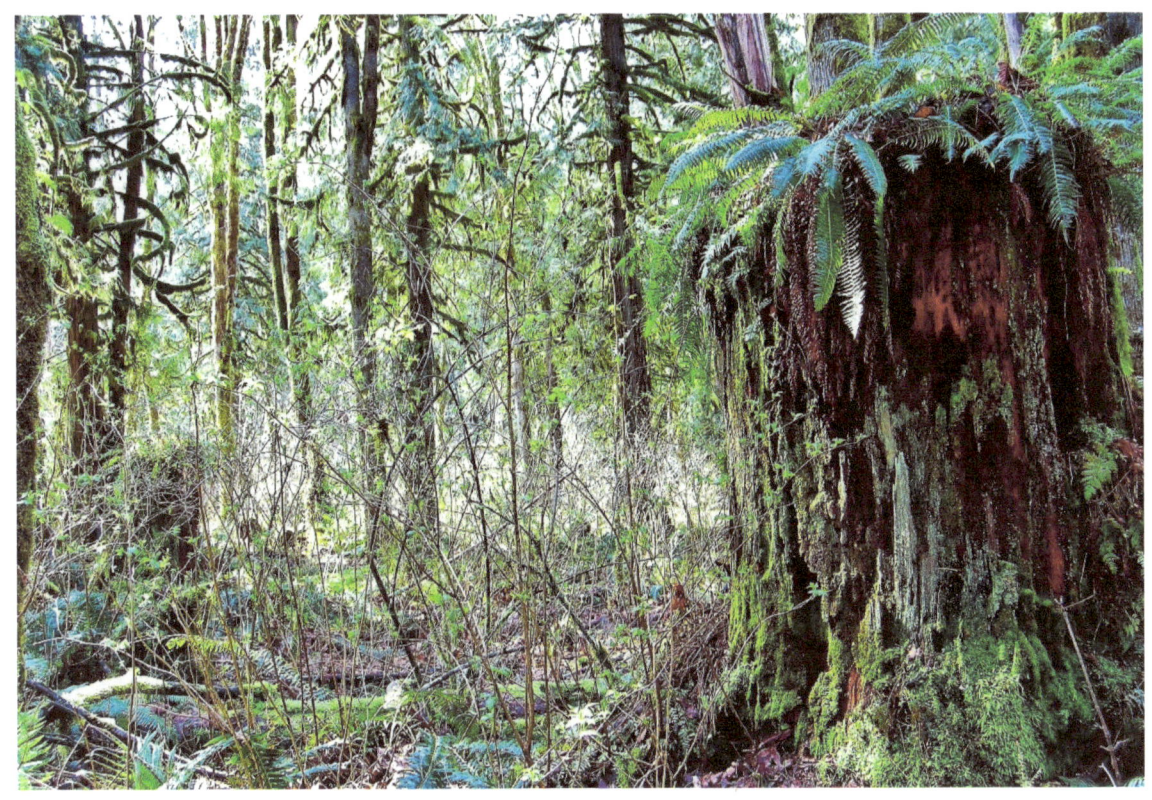

Rasar state park, Washington State

Woodlands

"There is a serene and settled majesty to woodland scenery that enters into the soul and delights and elevates it, and fills it with noble inclinations."

-Washington Irving

I've always loved to just stand in the woods and soak it all in; the peace, the quiet and stillness. Nature has a way of putting things into perspective. As our world fills with more technology and artificial things, I think that this escape and renewal becomes even more important. Find a forest somewhere, pitch a tent and breathe it all in!

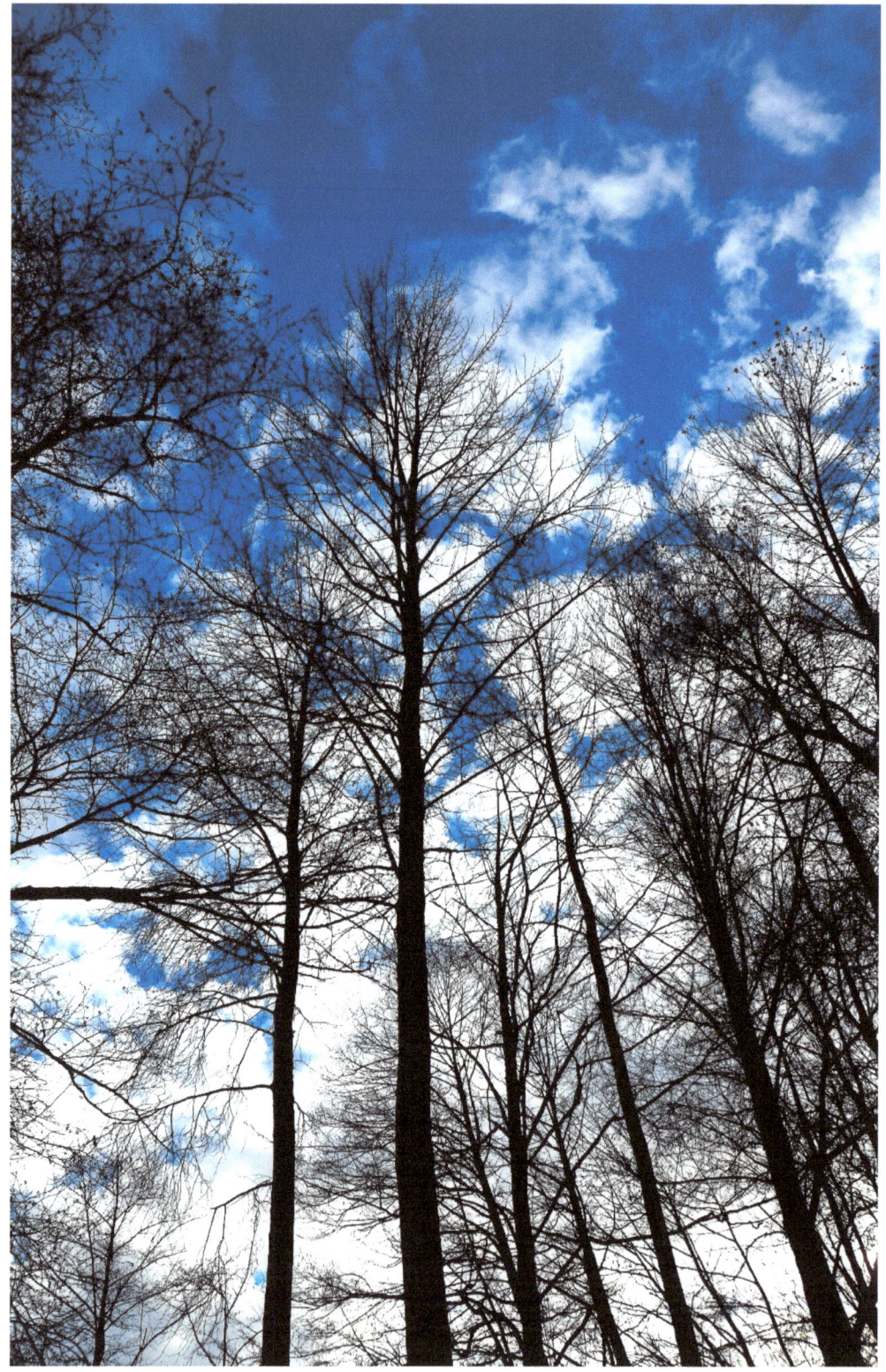

Alder and Cottonwoods just down the street from my house.

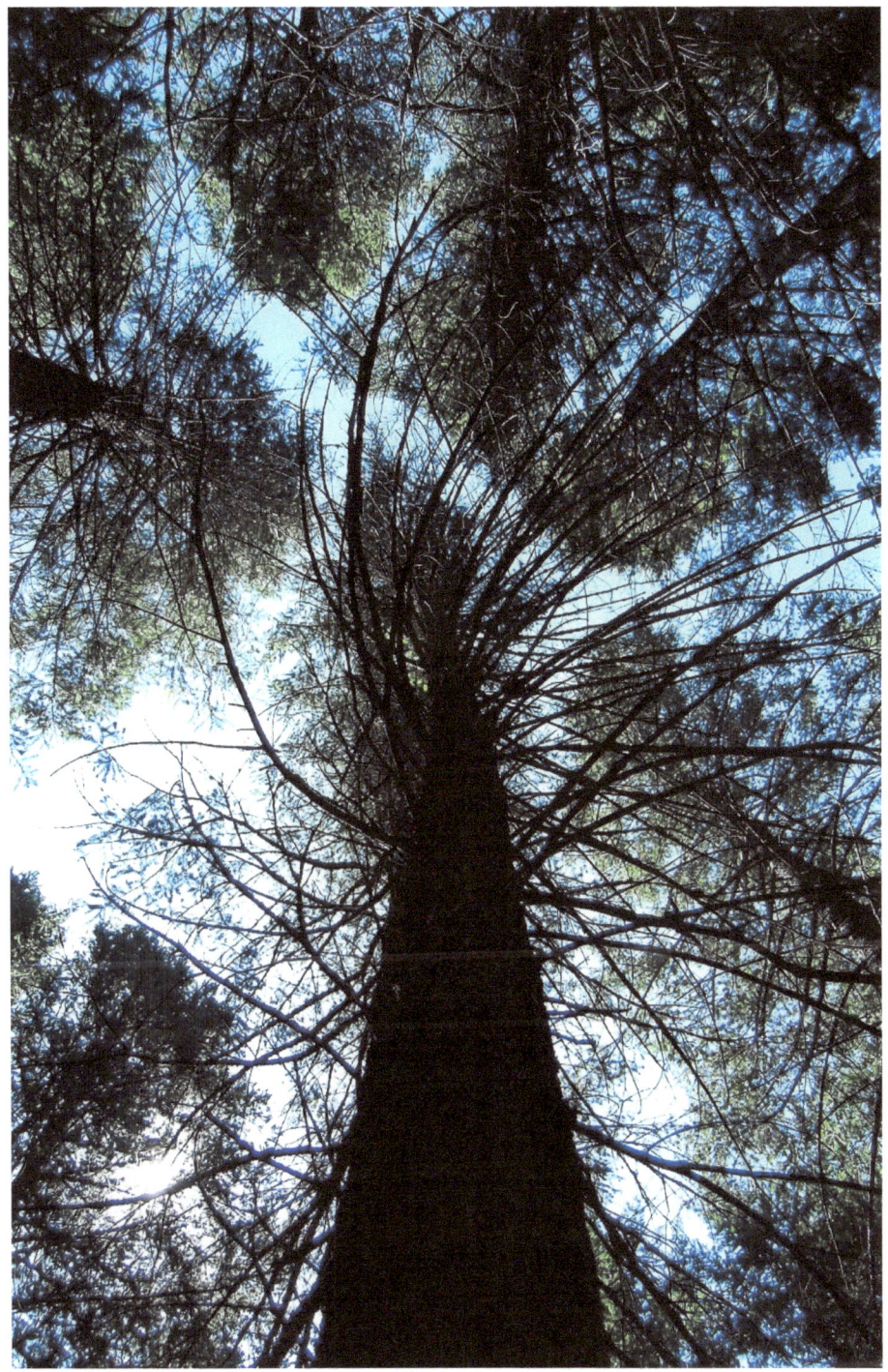

A grove of evergreens grow in a very unique spot in Montana, called the 'Montana Vortex'. Notice how the branches are all swirling in one direction? It is claimed that this is because of the magnetic energy that swirls up from the ground here, an unexplained phenomenon.

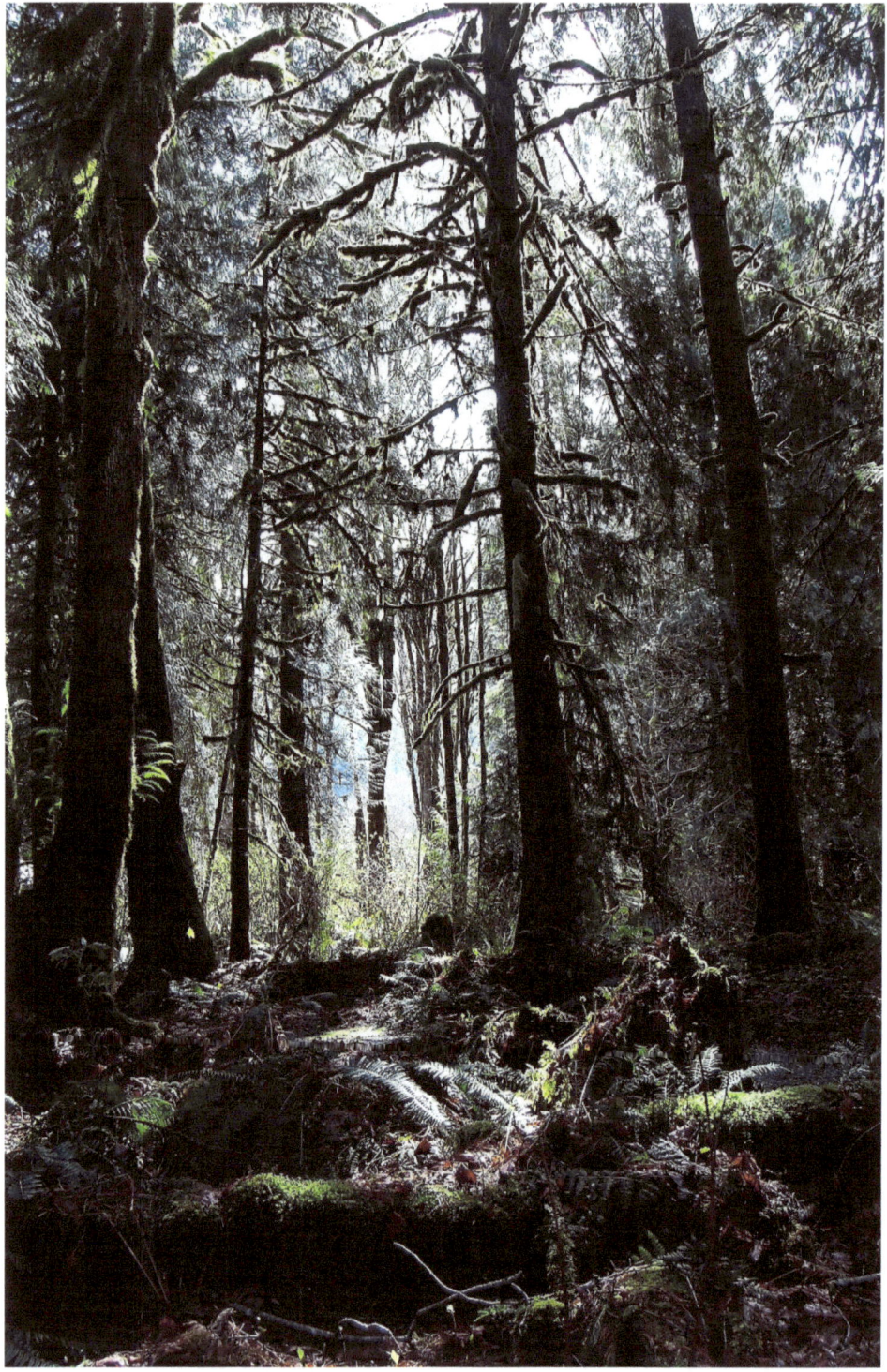

This is what the rainforests look like around the Pacific Northwest; lots of moss and ferns. There are, or course, plenty of rainy days. But on the sunny ones, the beauty can't be beat! This photo was taken at Rasar State park, in Washington State.

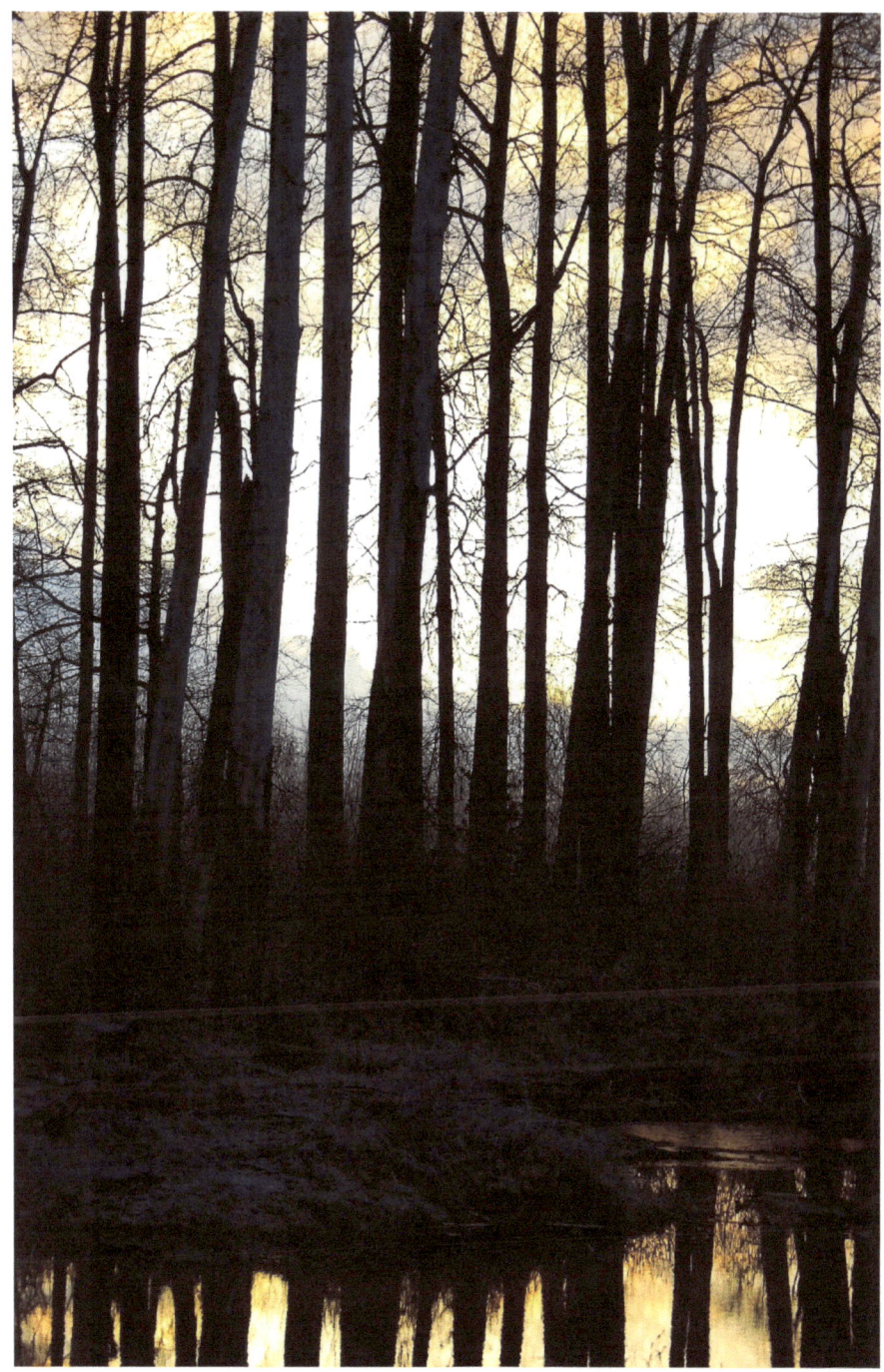

I am blessed to have a unique ecosystem right in my own backyard. It's called Hart's Slough and was the original course of the Skagit River. (Skagit Valley, Washington State) It was blasted over a hundred years ago to change the course of the river (flood control), which created this area that fills with water during flood season. The rest of the year it is home to a variety of wildlife, and haunting woods.

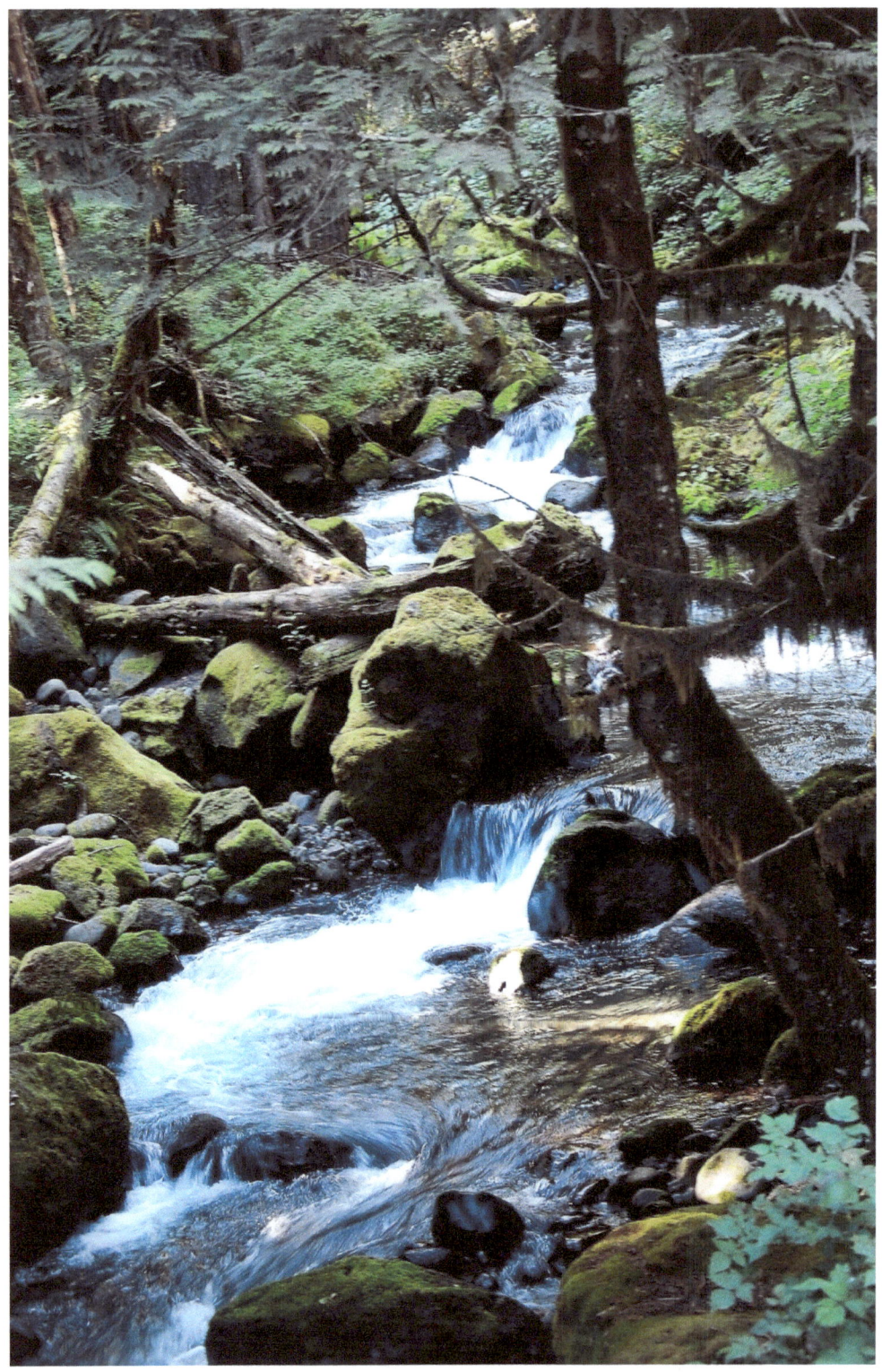

Mount Baker National Park

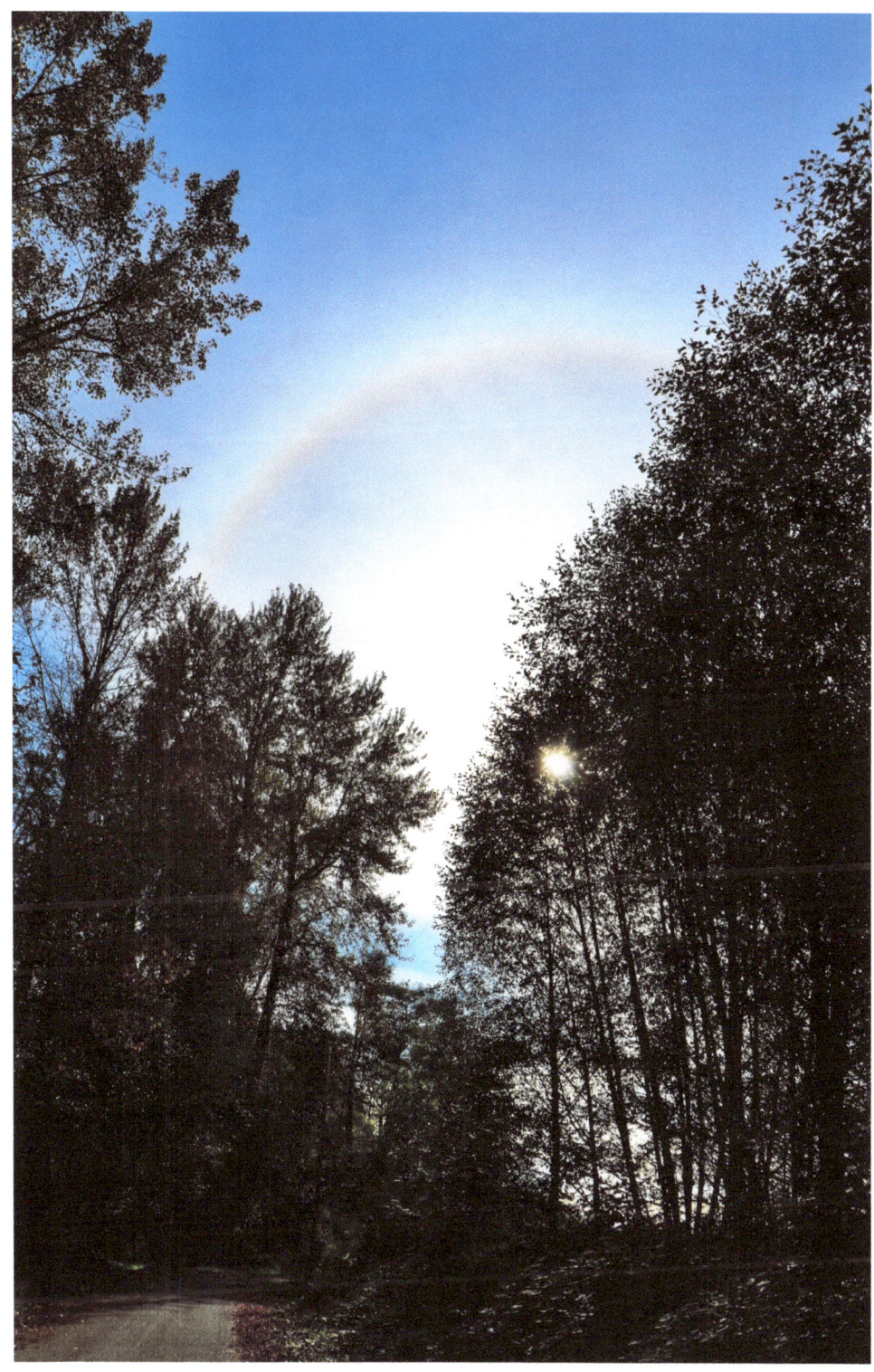

The road near my house

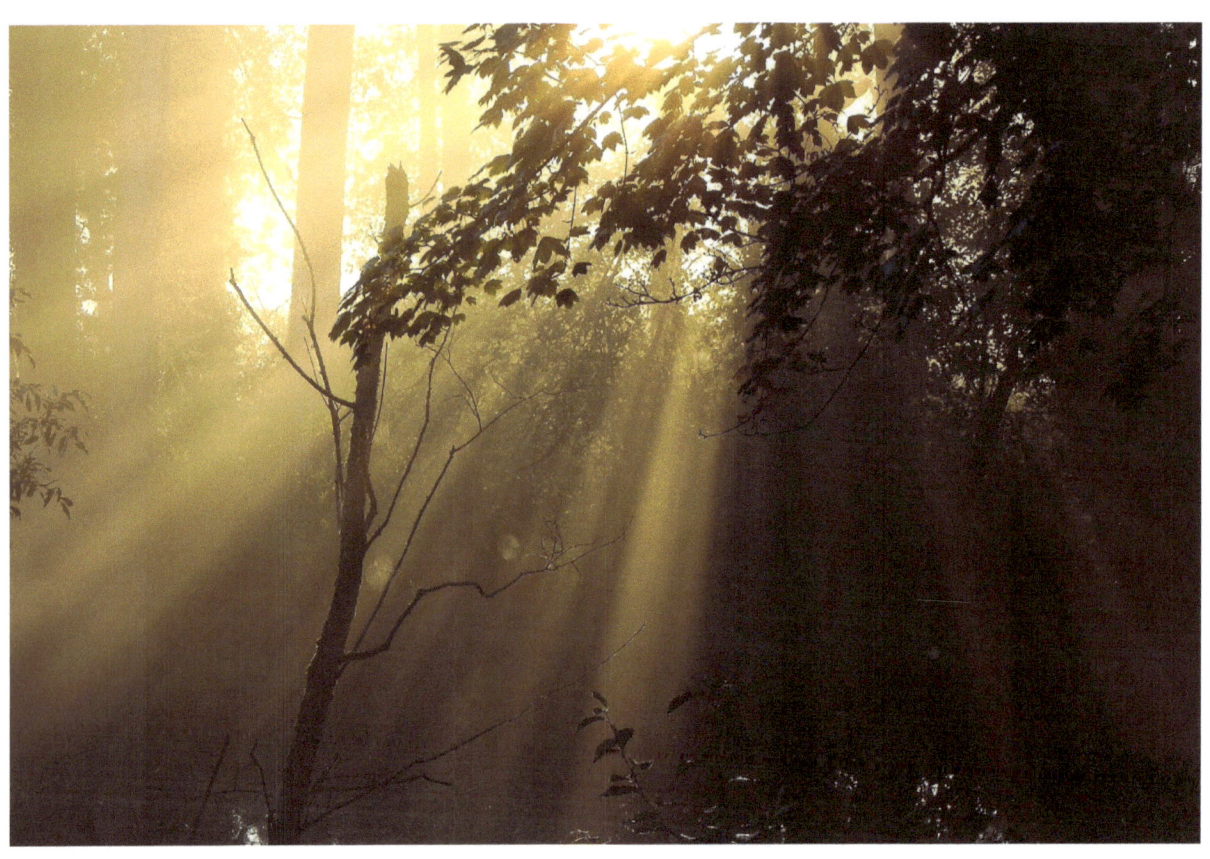

Valleys

"Happiness resides not in possessions, and not in gold, happiness dwells in the soul."

-Democritus

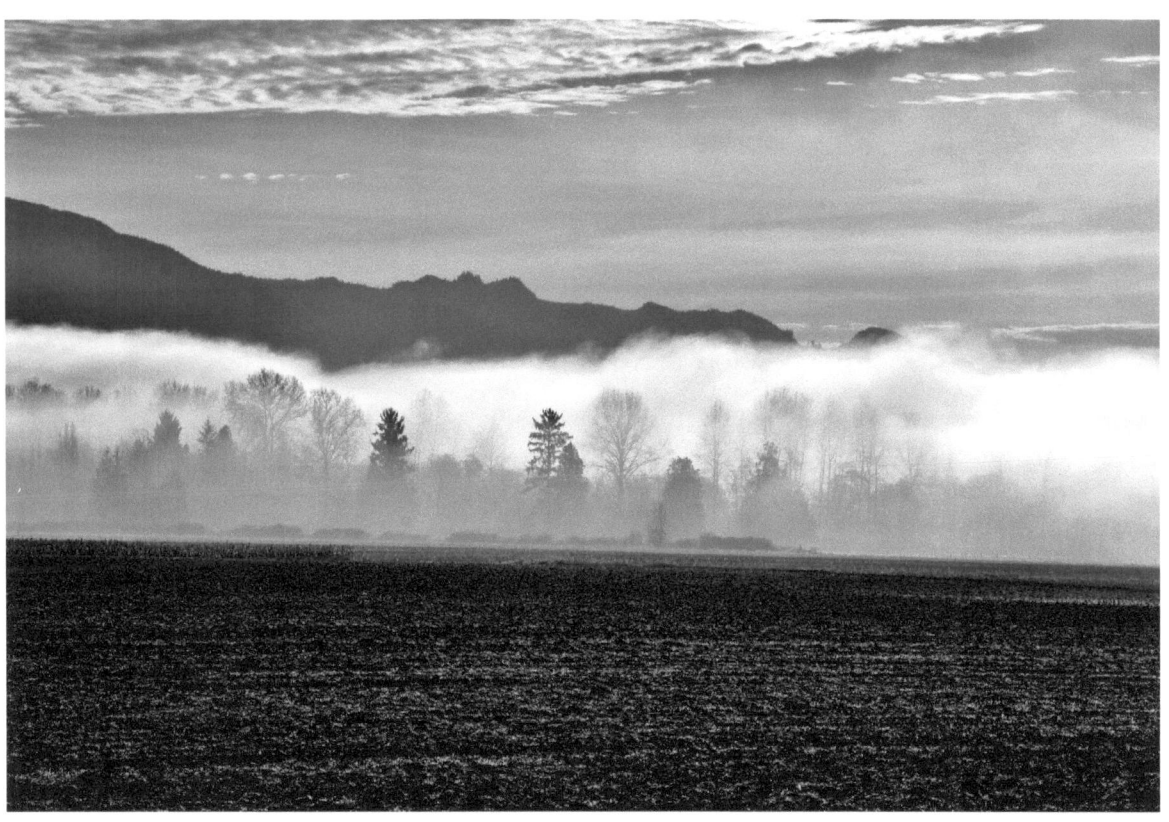

Farmland in the early morning fog

Skagit Valley, Washington

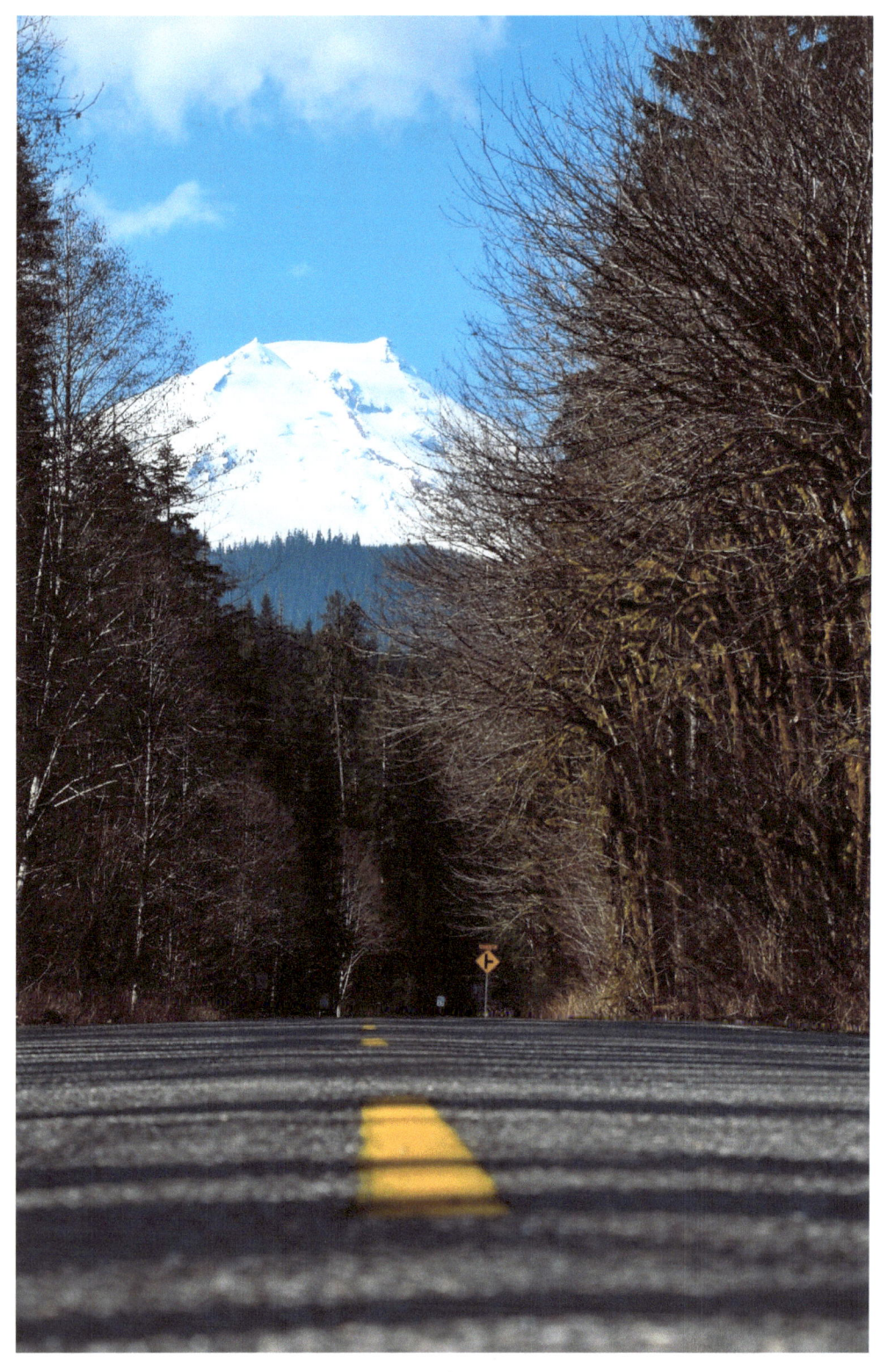

Mount Baker, Washington

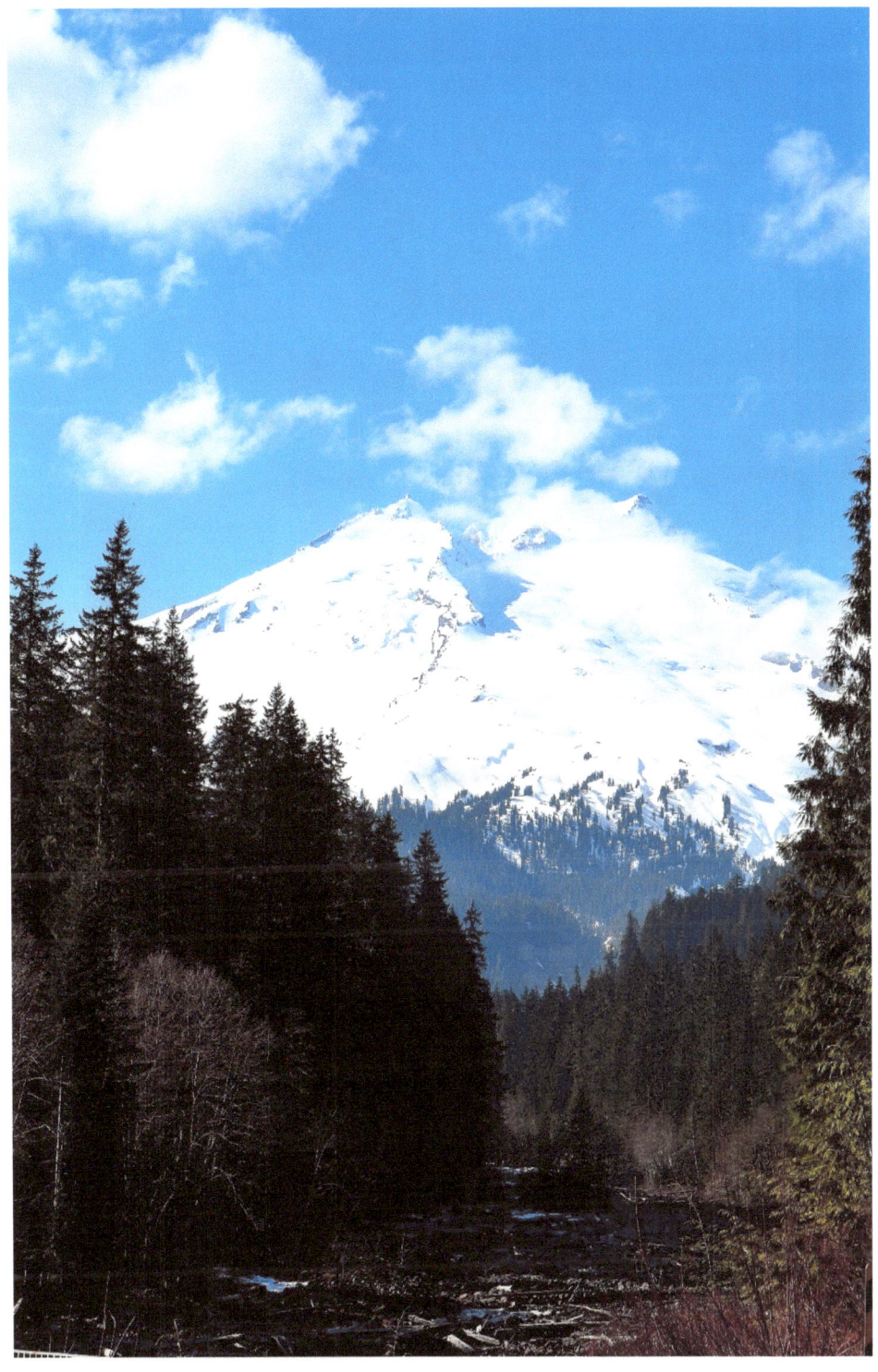

A closer view, looking up the valley

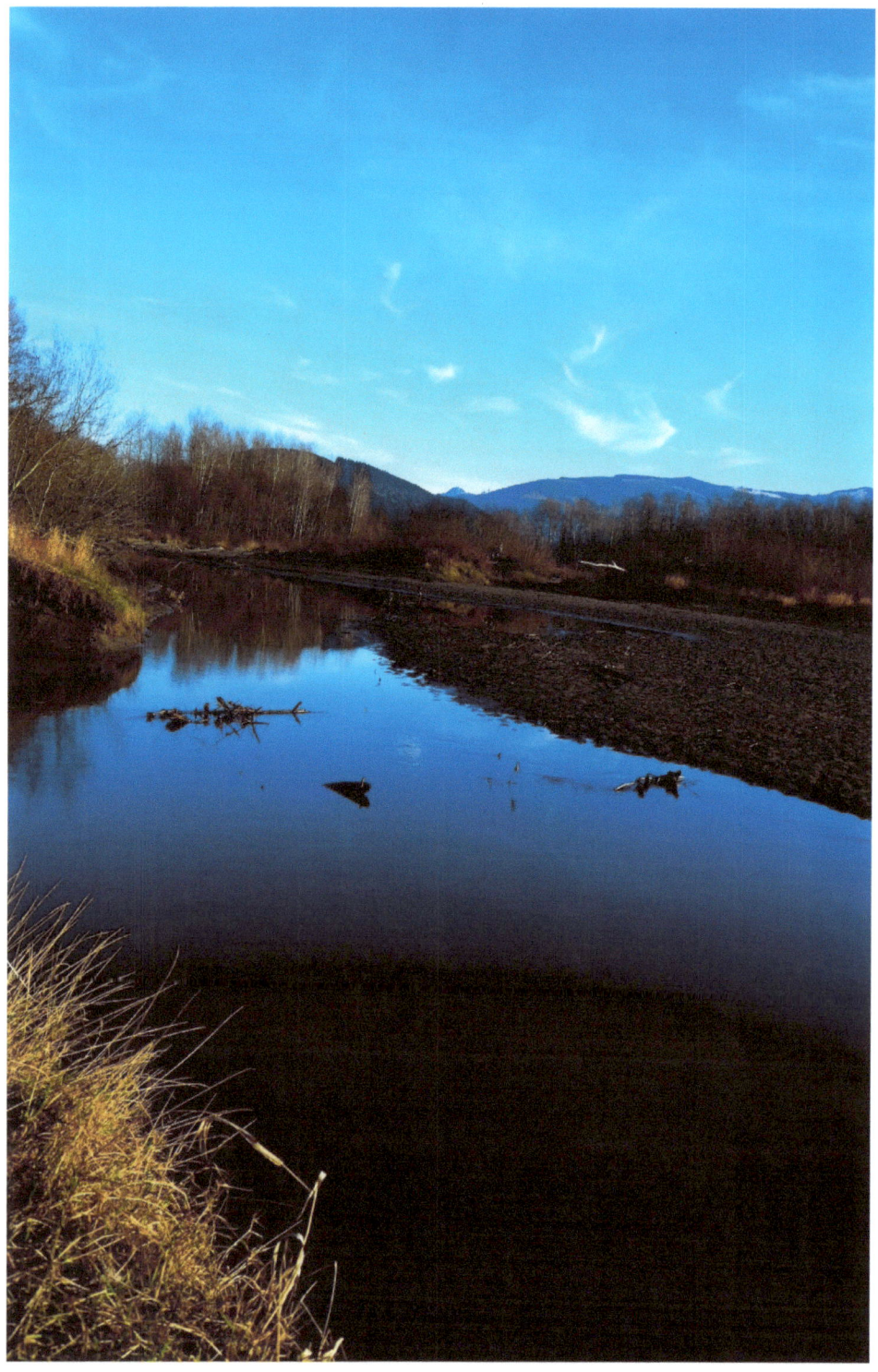

Skagit River in Skagit Valley, Washington

The Skagit on a crisp fall day

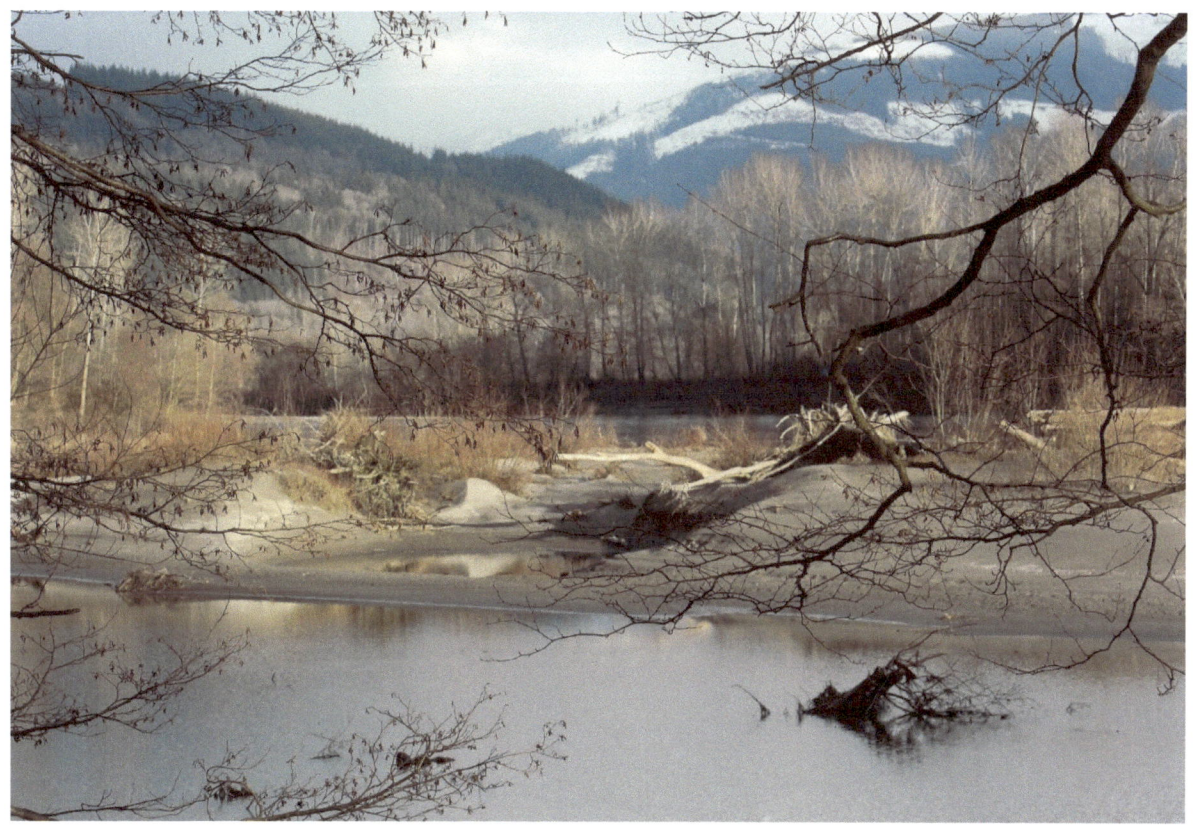

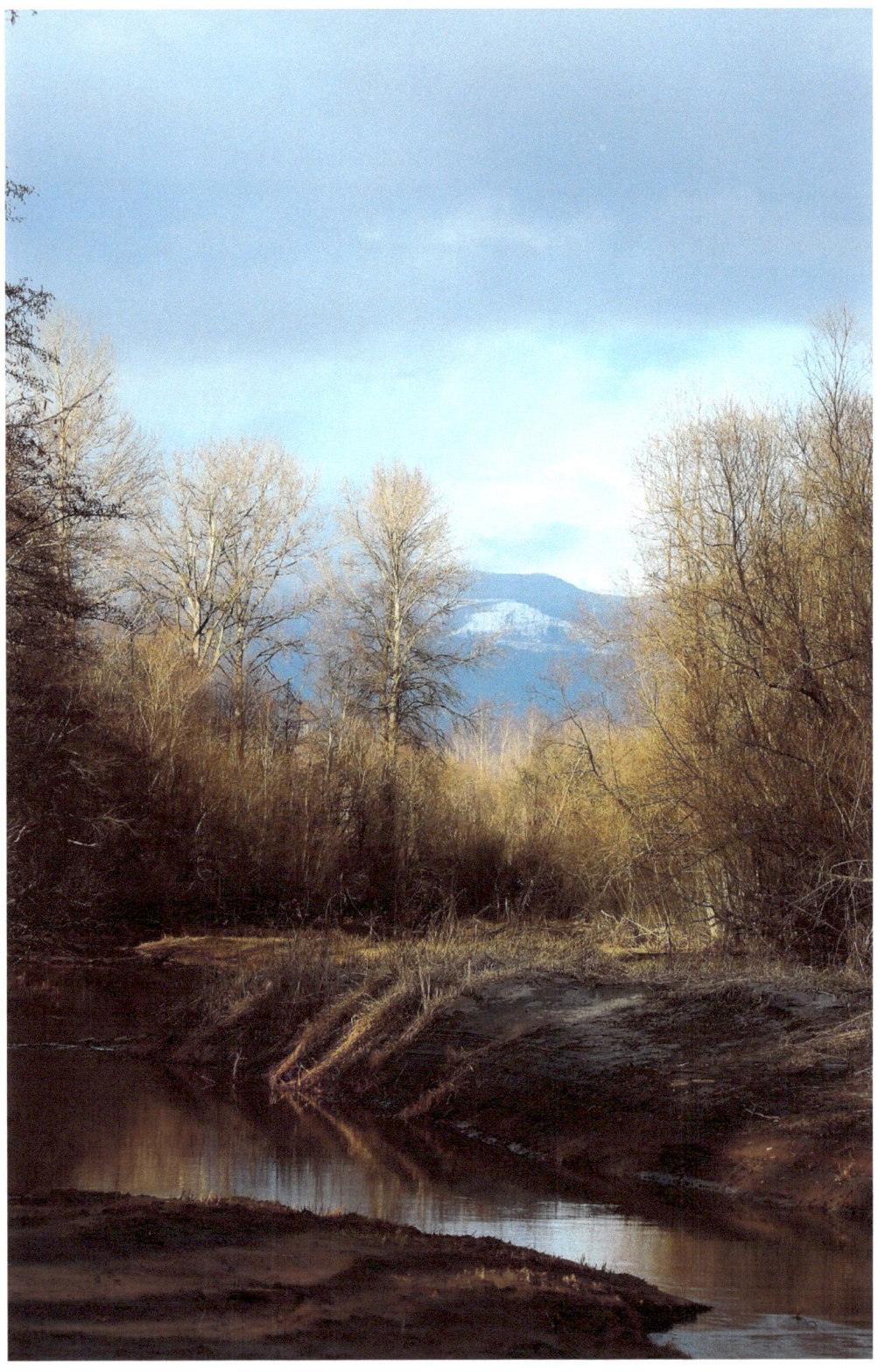

Another view of Hart's Slough. I call this image 'Silence'.

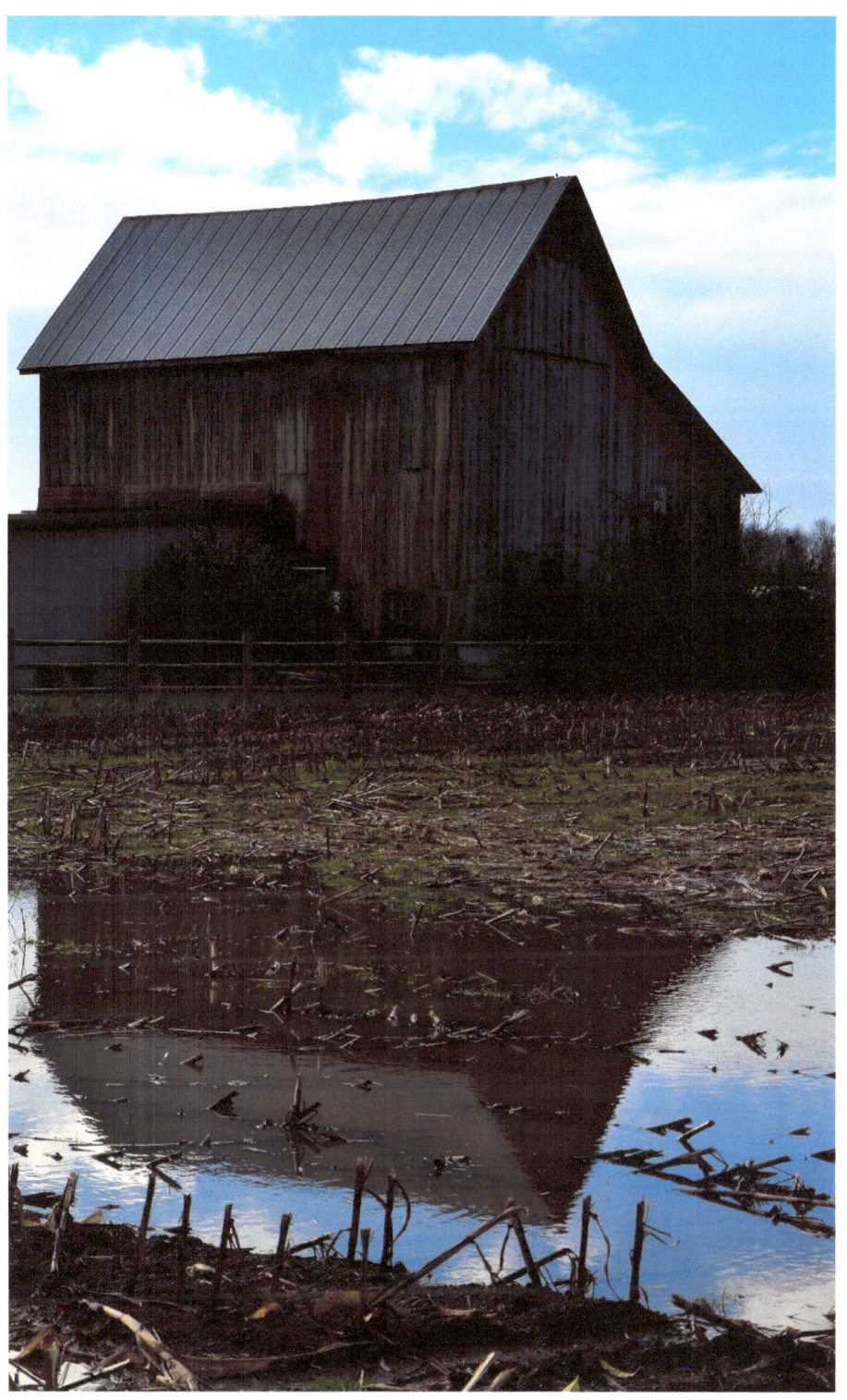

An old Skagit Valley farm

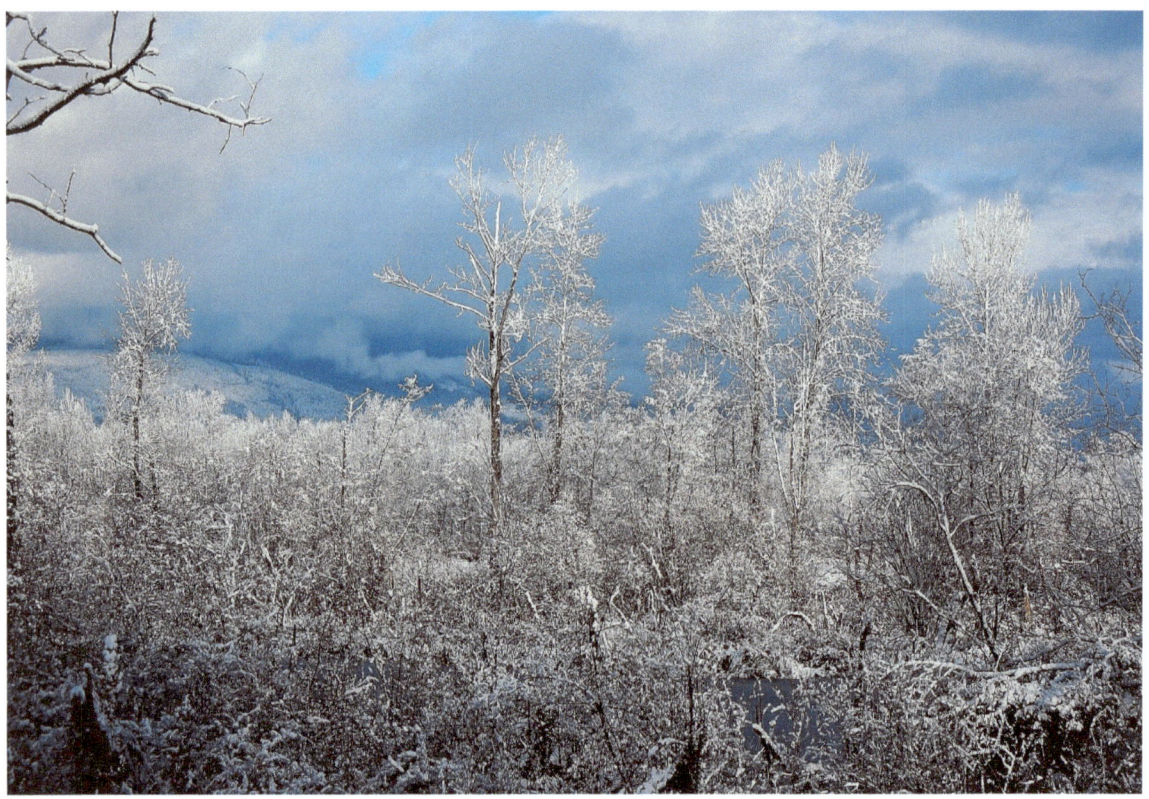

We don't get snow very often in the Pacific Northwest but when we do, it's stunning!

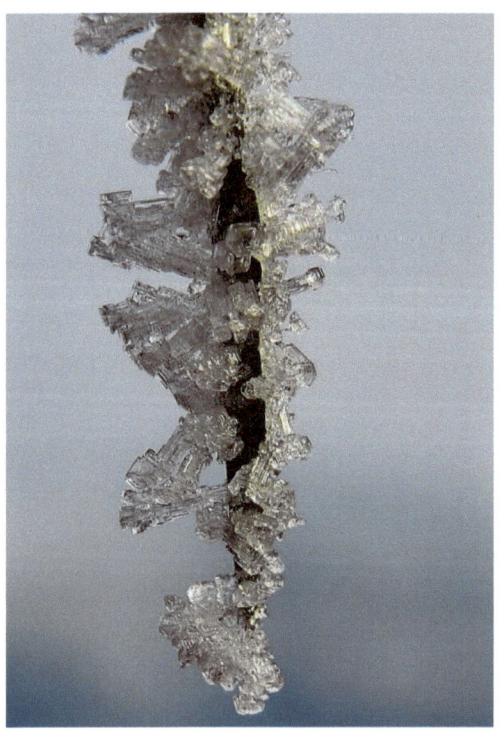

NATURE'S TAPESTRY

Ocean Scenes

"Roll on, deep and dark blue ocean, roll. Ten thousand fleets sweep over thee in vain. Man marks the earth with ruin, but his control stops with the shore"

-Lord Byron

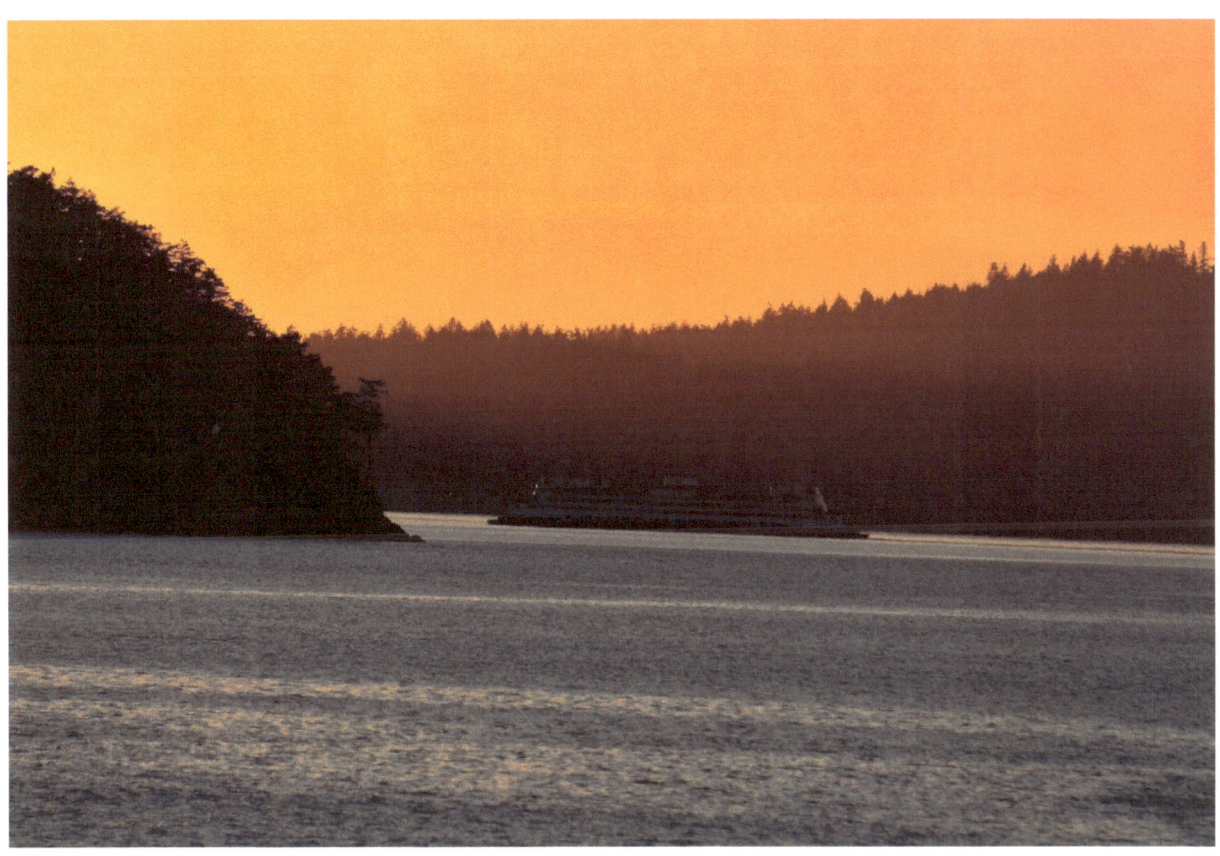

Washington is one of the unique states that has a desert at one end and an ocean at the other, with a mountain range full of volcanoes in the middle! This image was taken while on a ferry in the San Juan Islands, Washington.

The San Juan Islands are full of wonders, both natural and manmade. You could spend days riding one of the many ferry's to each of its popular ports. A hiker and biker's paradise; there are miles of trails, including Moran State Park on Orcas Island.

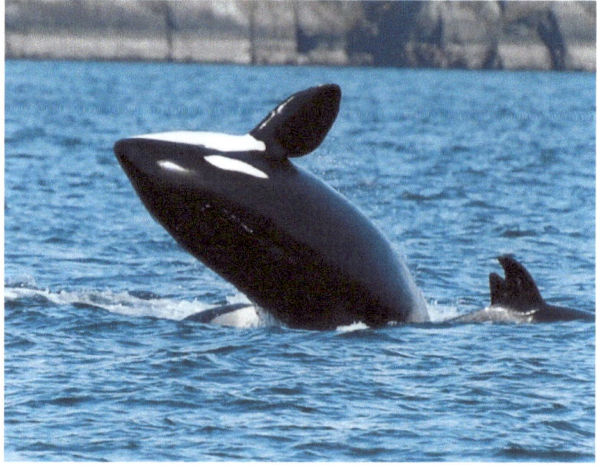

Puget Sound is home to several killer whale pods. The Orcas can weigh in excess of six tons.

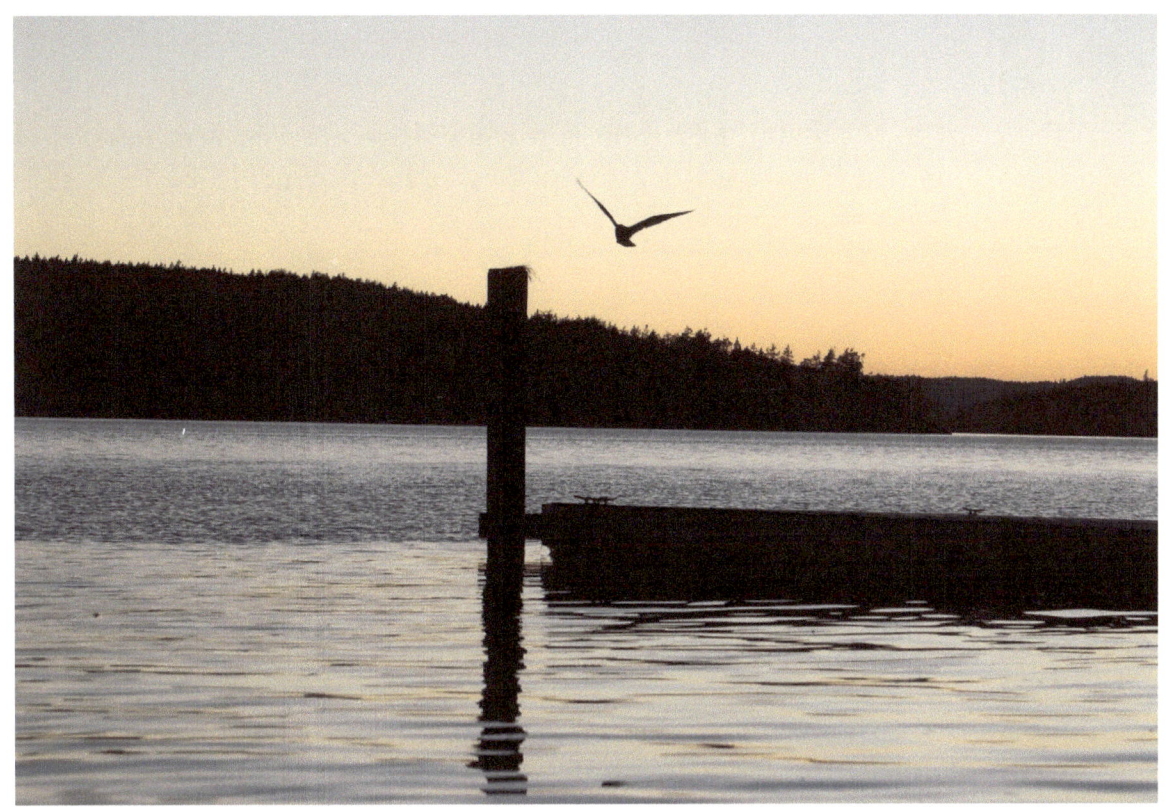

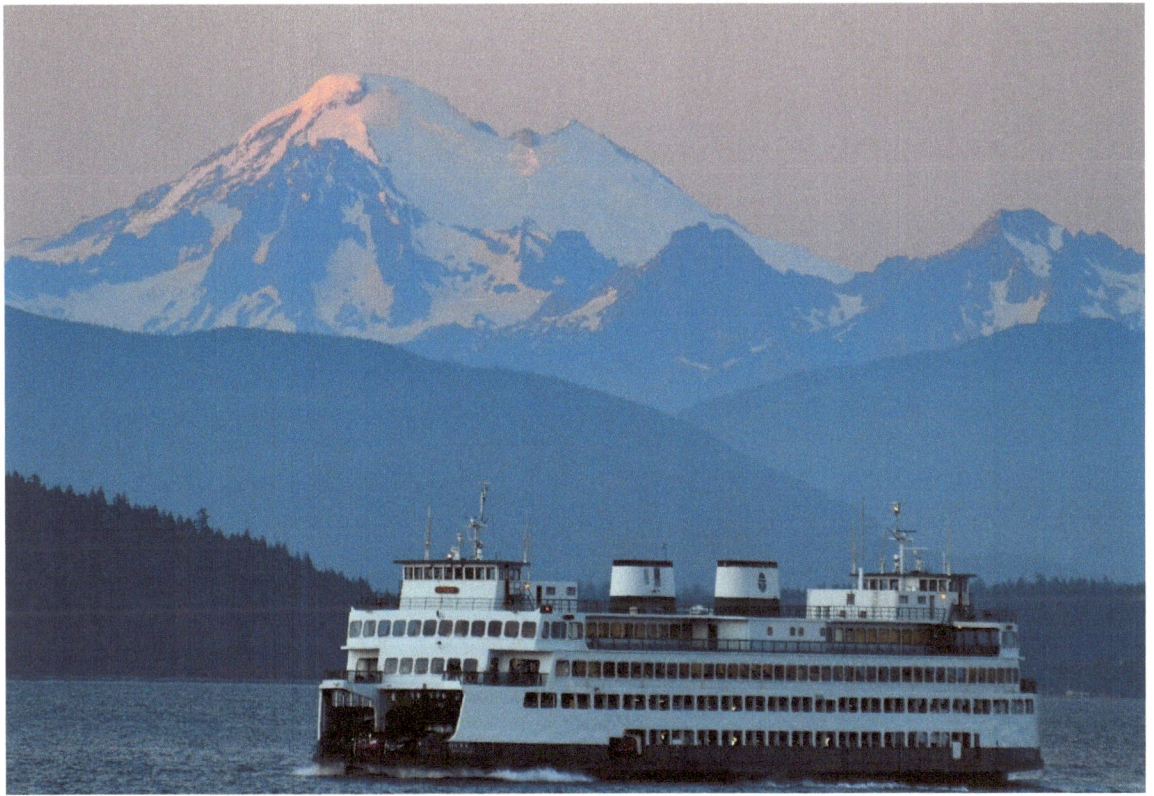

Just down the coast in the state of Oregon is a white sand beach called Seaside. I have been coming to visit Haystack Rock for as long as I can remember. Its base is surrounded by tide pools filled with starfish and other sea life.

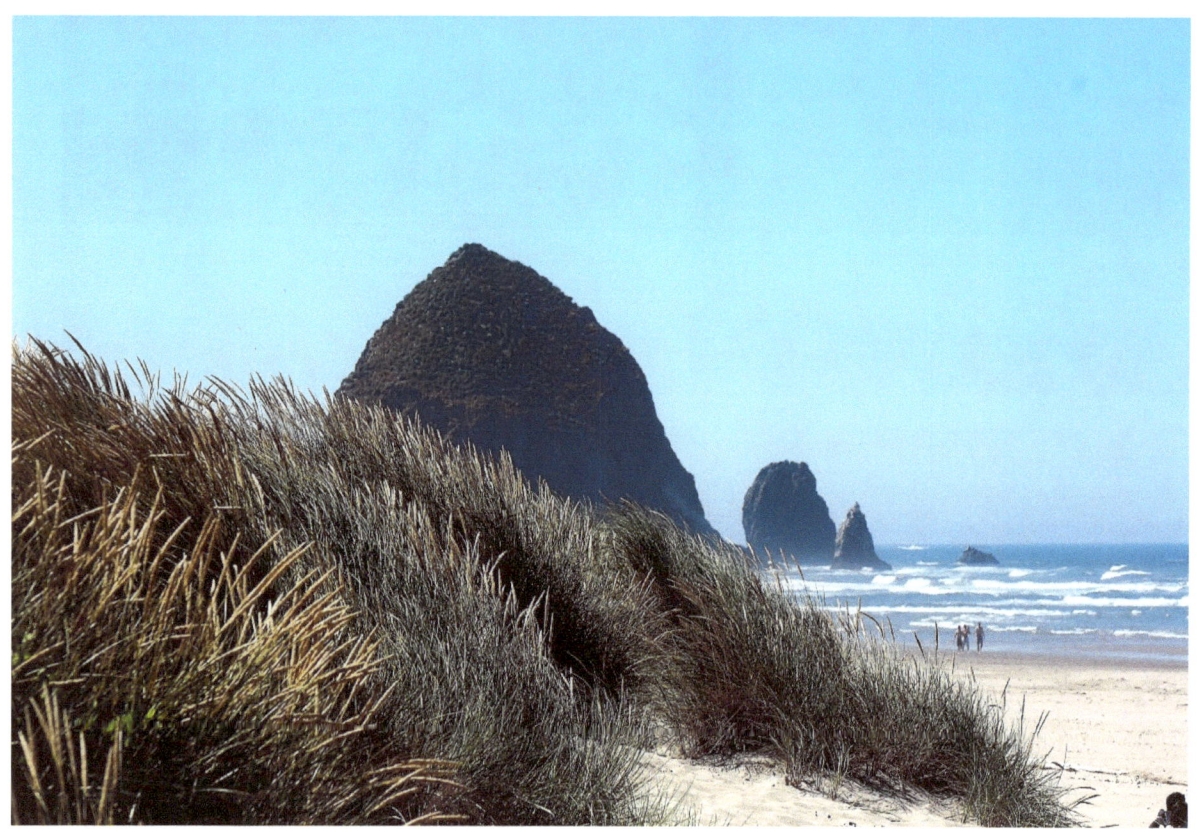

Seaside, Oregon

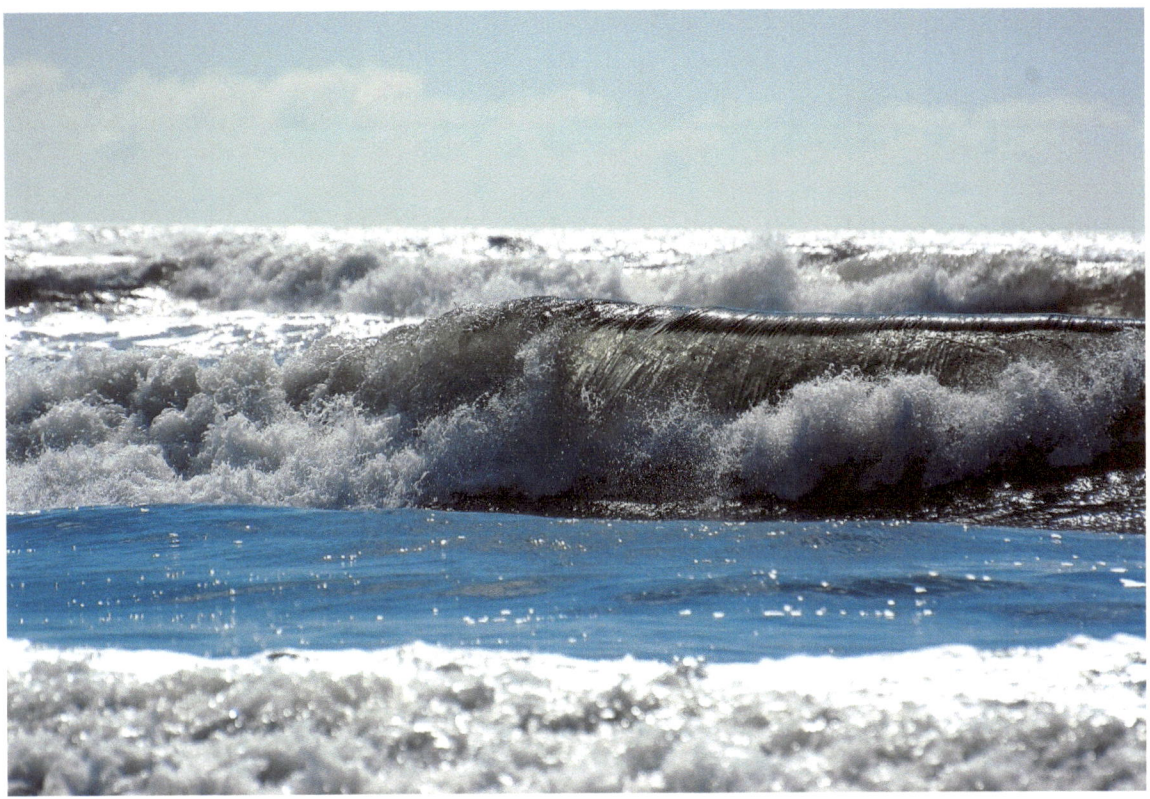

If you're brave enough to enter the frigid water, the waves are good for body surfing. When the weather is right, die-hard surfers don their wetsuits to ride the waves.

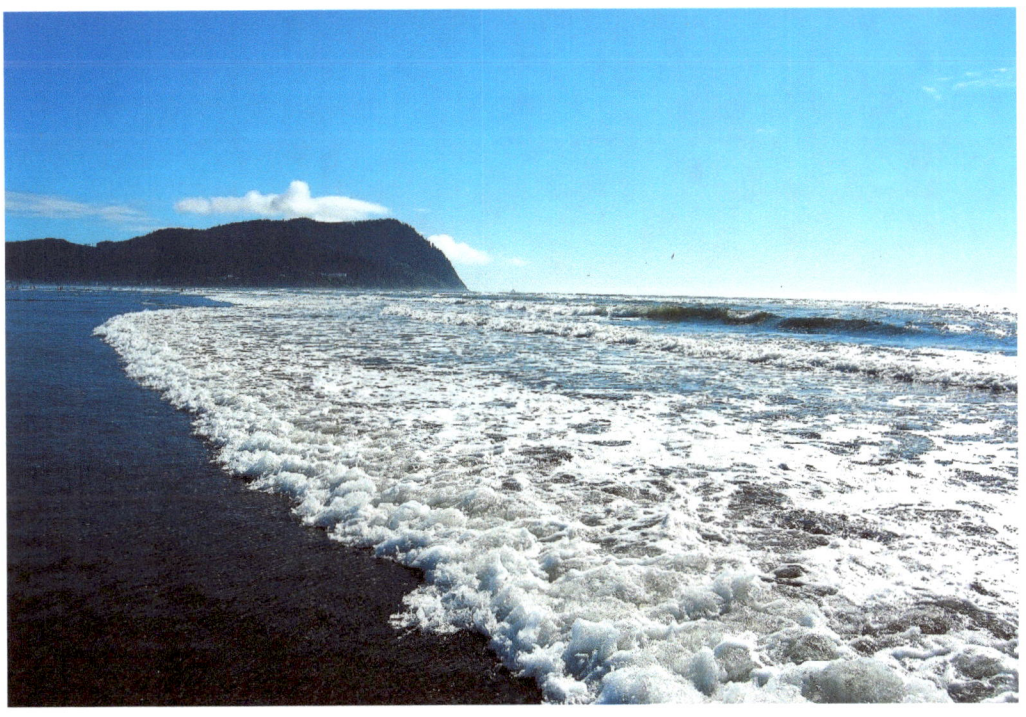

Lakes

So yeah, I know that lakes are everywhere. I could probably go to several locations in every state in the country and come up with something unique and beautiful. However, some of my best memories have been spent on the shore of a lake and some of my favorites pictures come from the same places. So…I am compelled to share them!

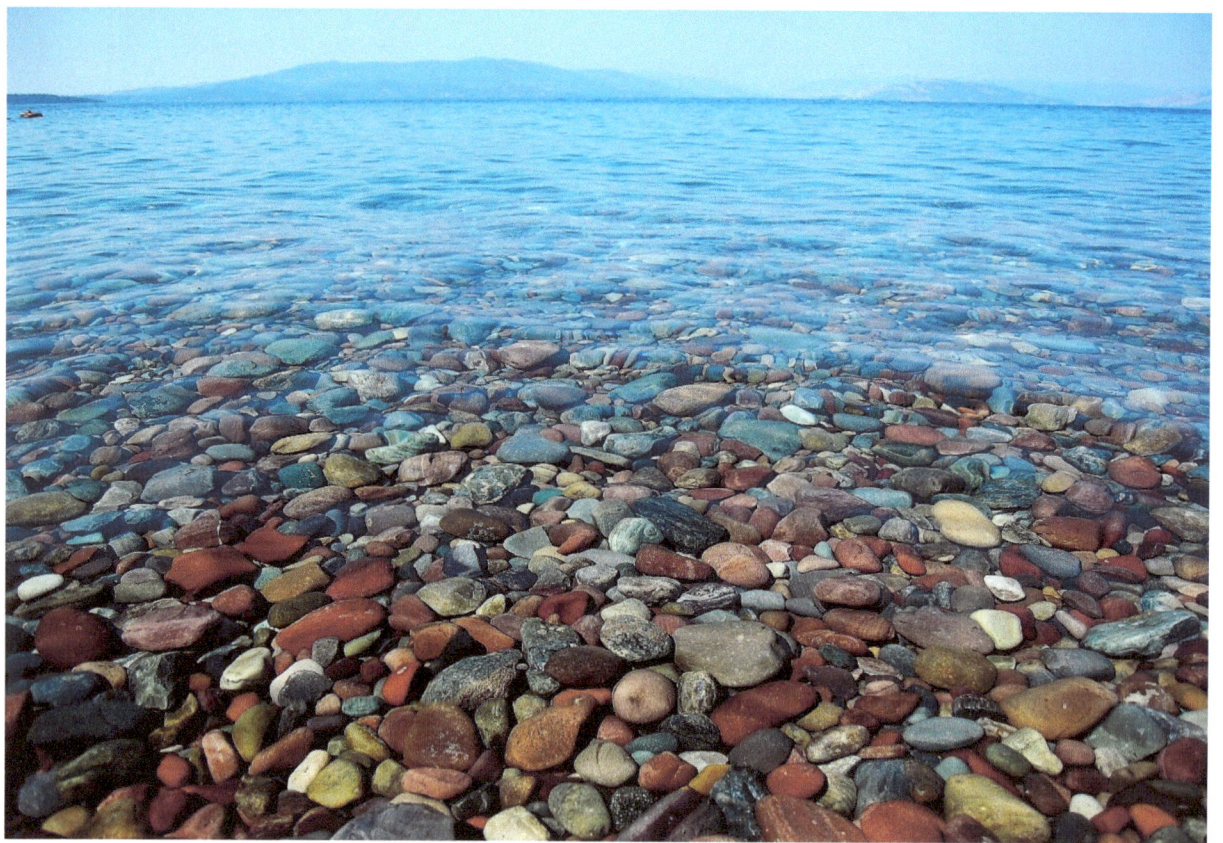

Blue Bay, Flathead Lake, Montana

I can't say enough about Flathead Lake. It has been the site of many family reunions and going back makes me feel like a child every time. The water is the clearest I have EVER seen. Seriously. The image above starts out in about two feet of water and quickly drops off to over twenty. You can be out swimming in twenty to thirty feet and still look down and see the bottom.

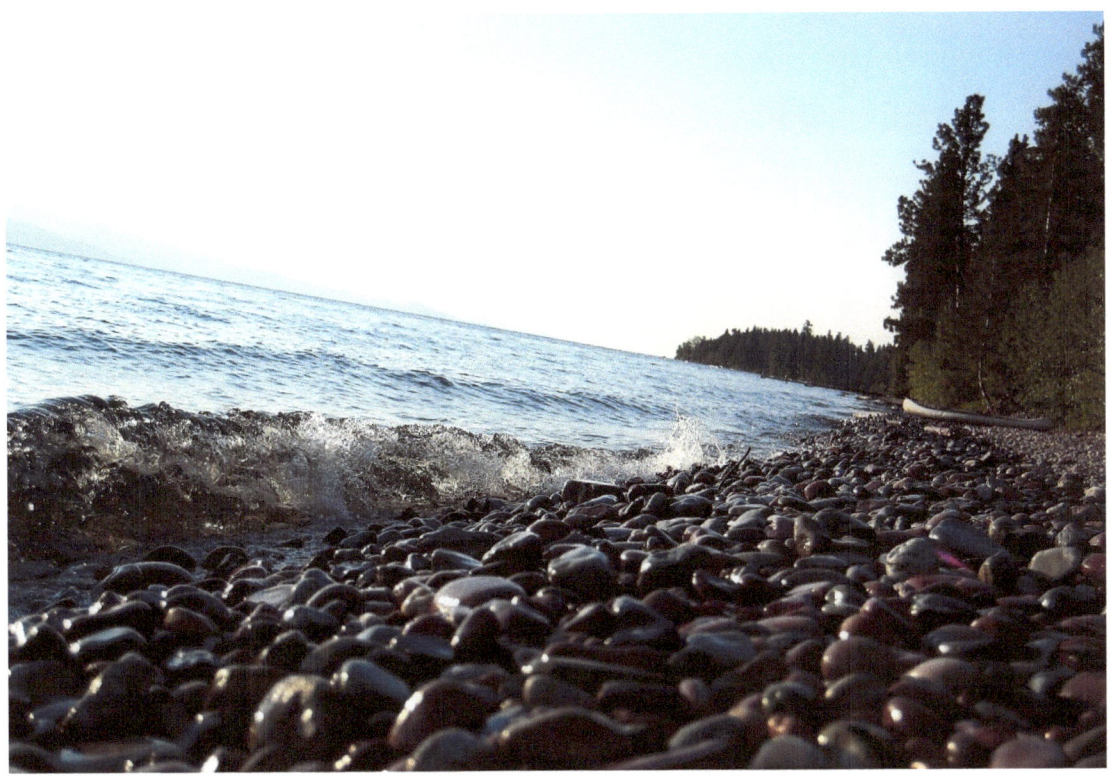

Flathead Lake, Montana

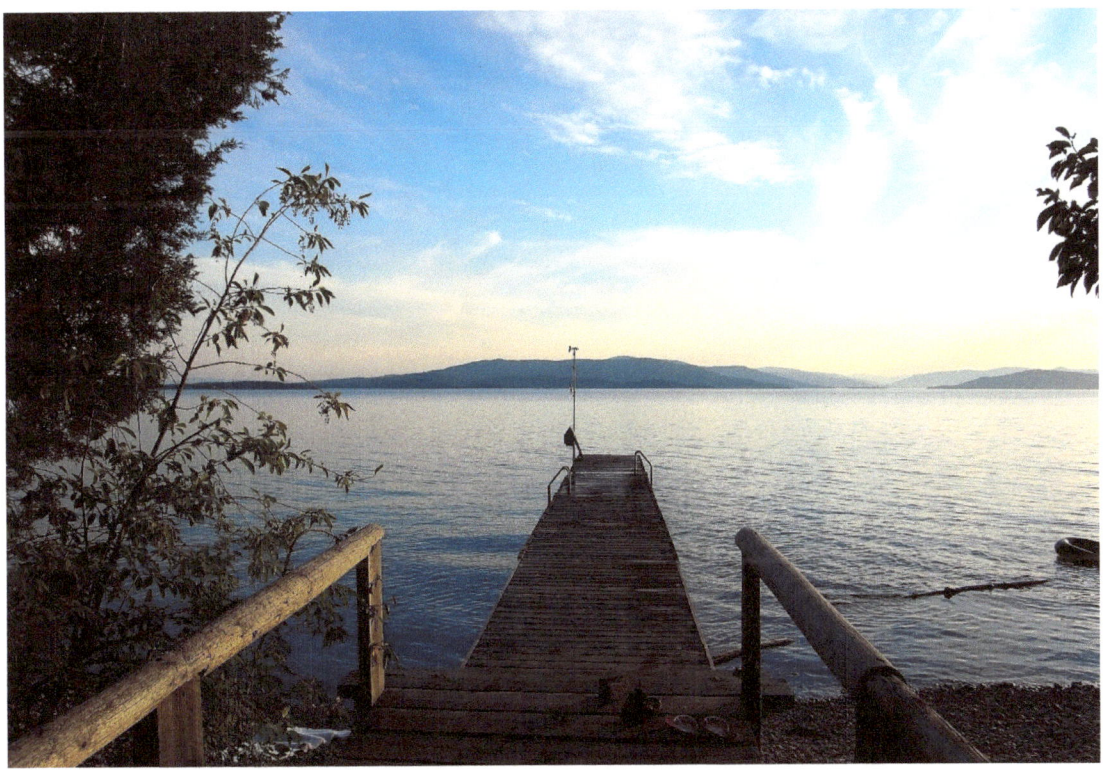

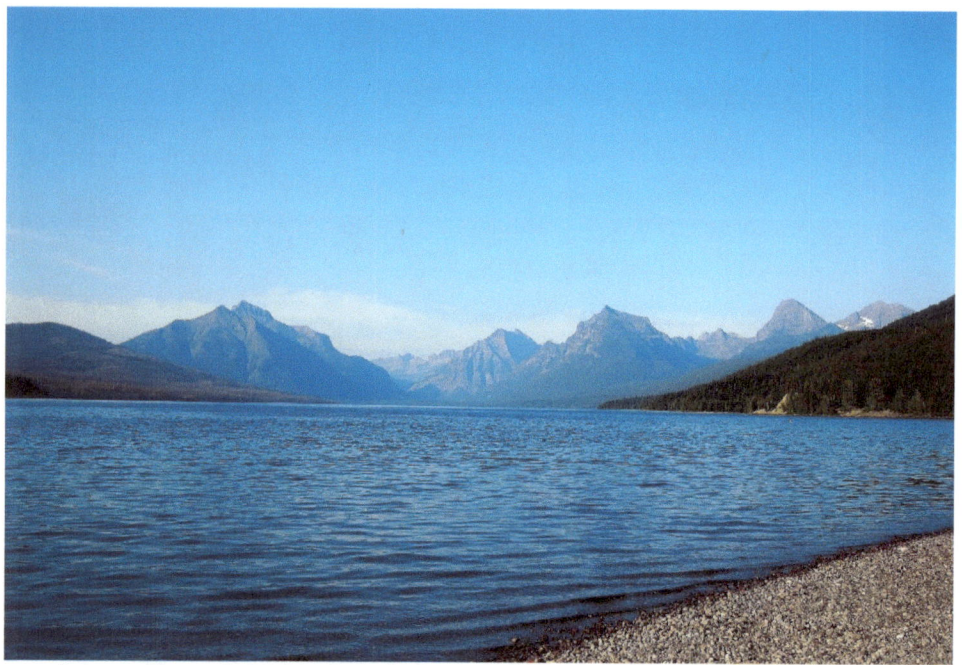

Just up the road to the North of Flathead is Glacier National Park, Montana. Pictured here is McDonald lake, located near the main campground.

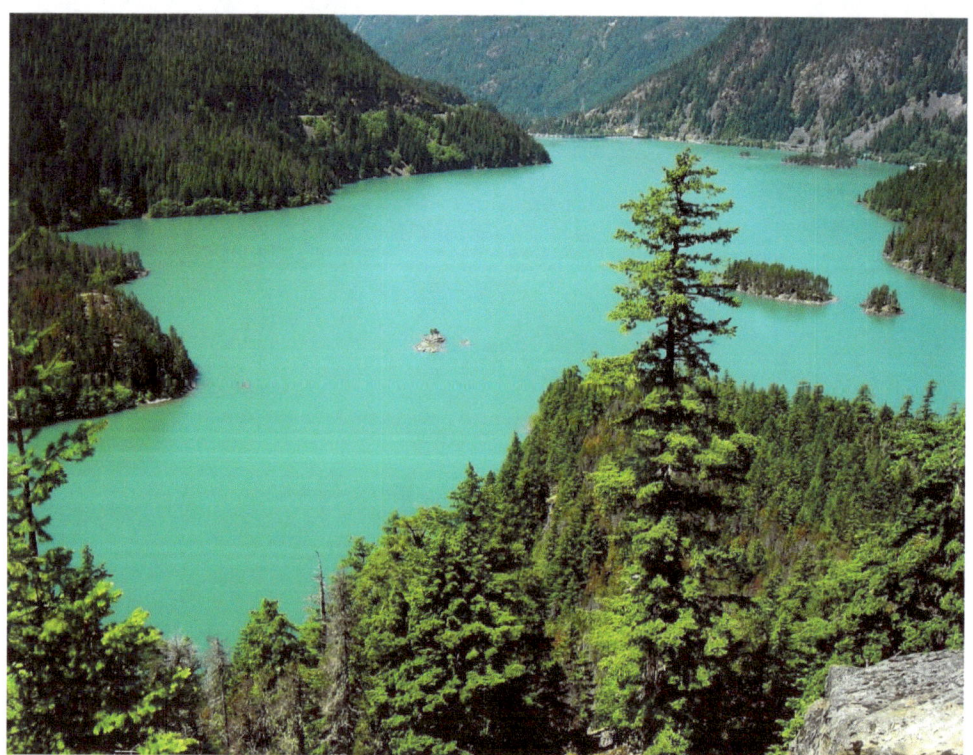

Finally, a lake closer to home in Northern Washington. Near the top of the Hwy 20 loop is Ross Dam. Seen here is Ross Lake, and yes the water really is that amazing color! It's said to be caused by minerals.

Wildlife

*"Plans to protect air and water, wilderness and **wildlife** are in fact plans to protect man."*
- Stewart Udall

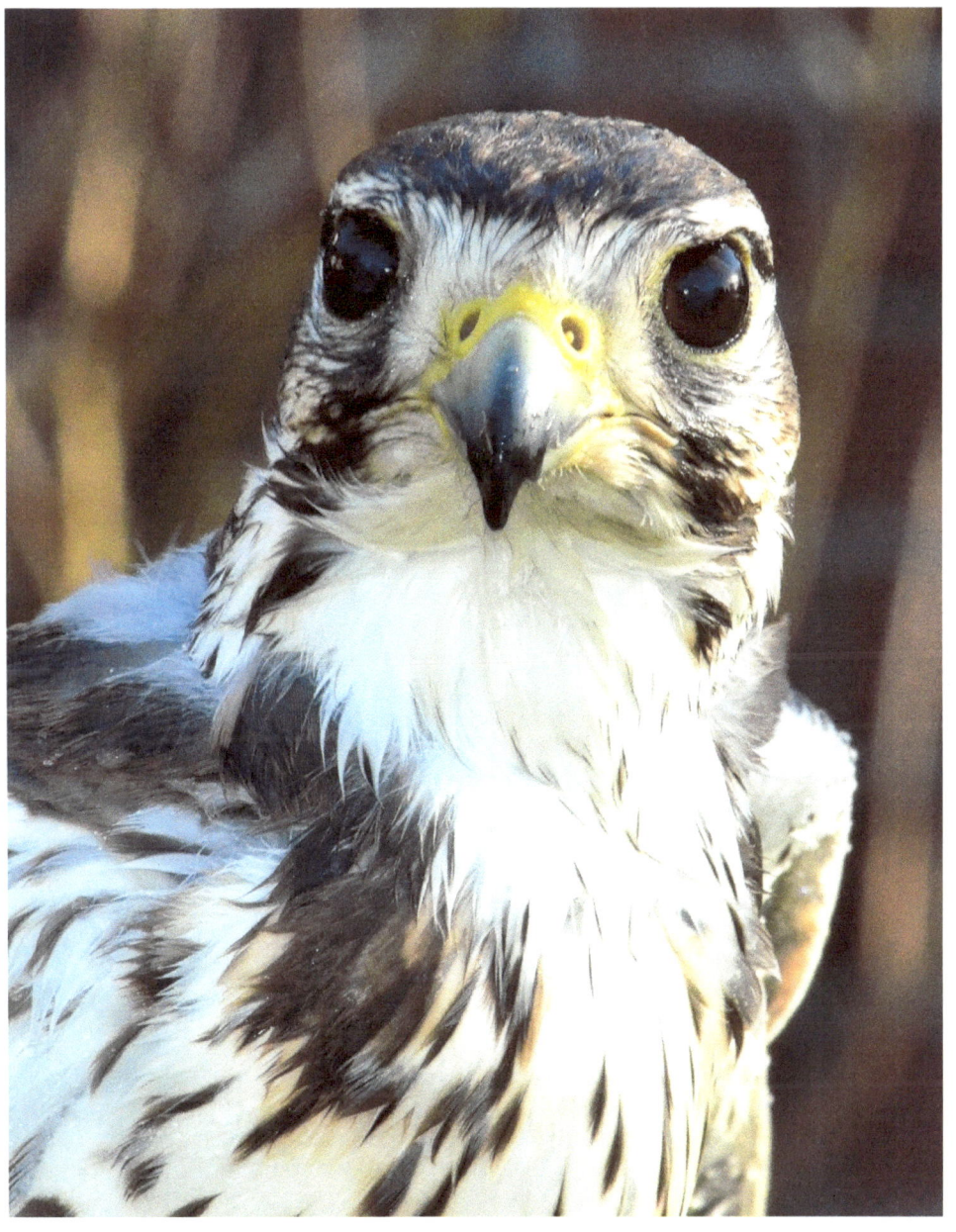

Prairie Falcon

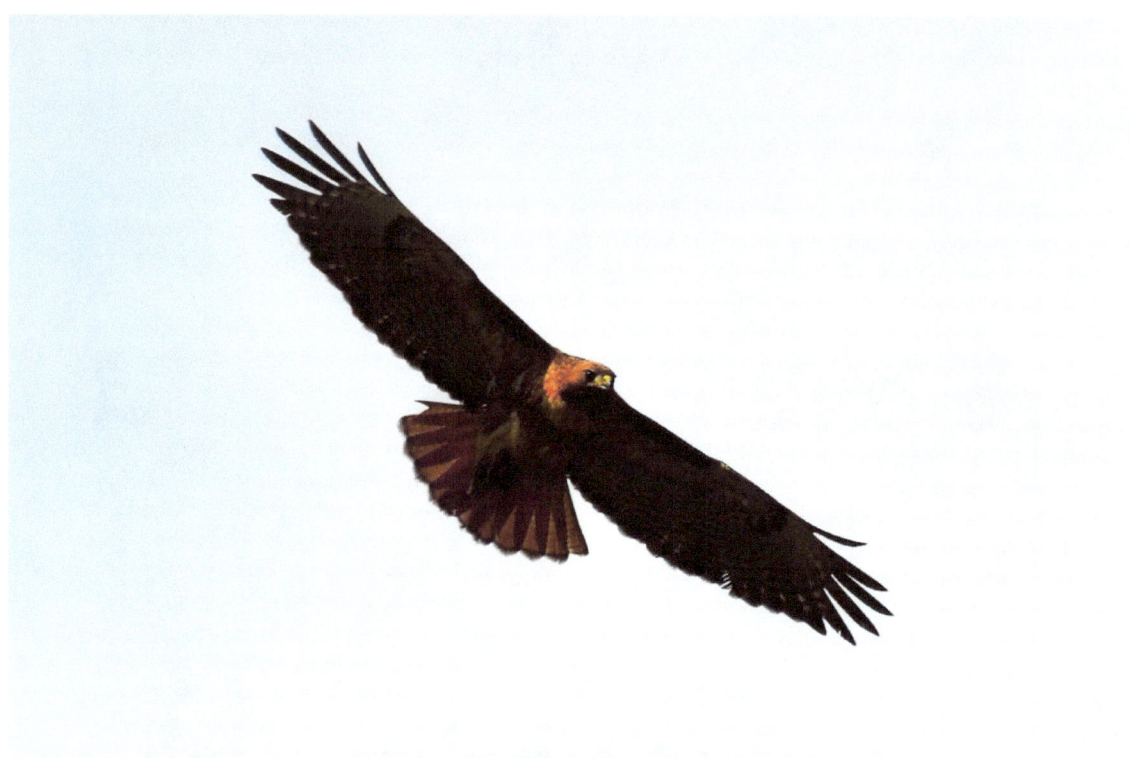

The farmland surrounding my home in Skagit County is full of wildlife, including the Redtail Hawk.

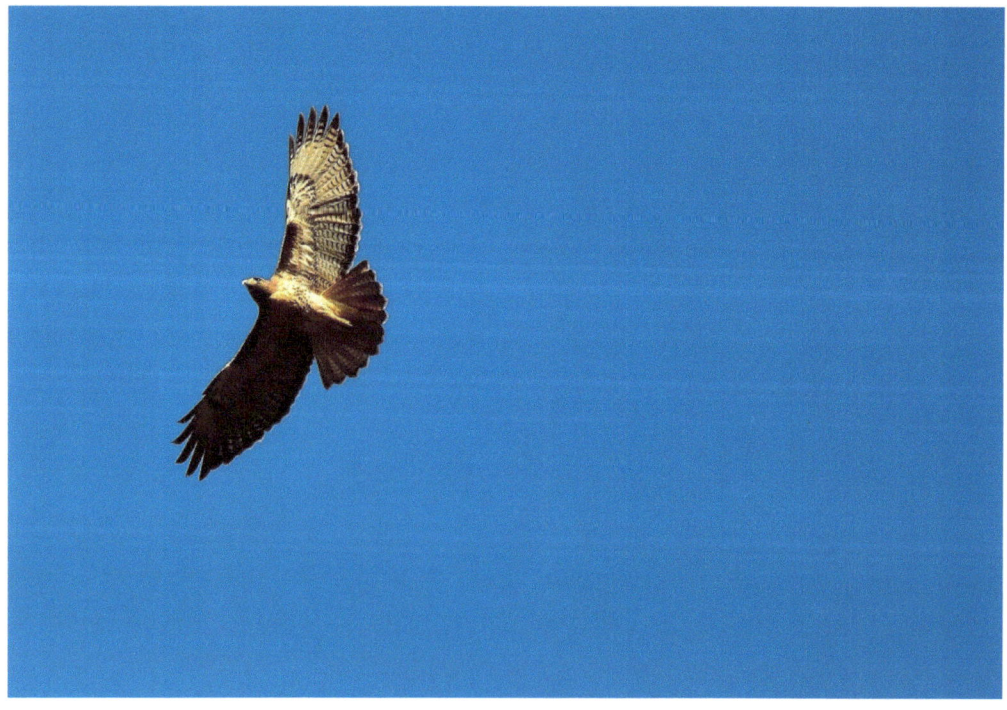

The Bald Eagle is the Washington State bird.

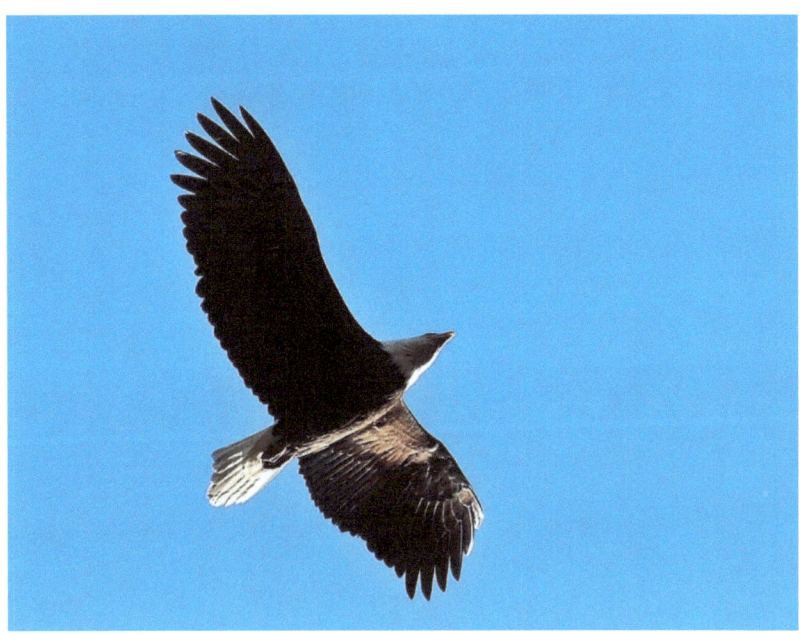

Sometimes the hawks get a little too close to the eagle's territory.

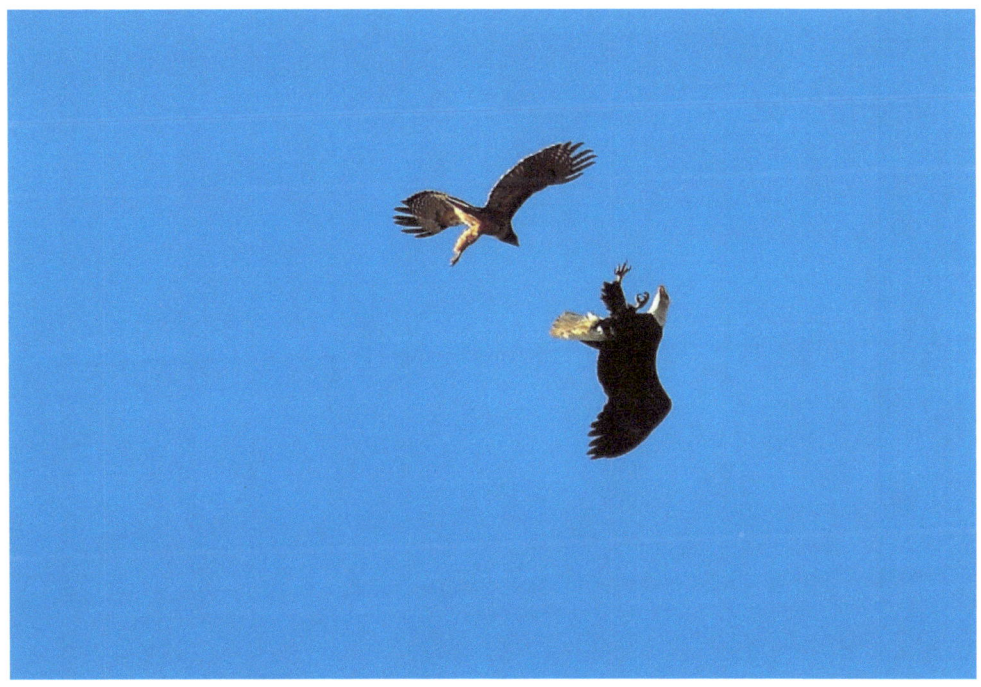

One of the most commonly seen waterfowls in the valley are geese.

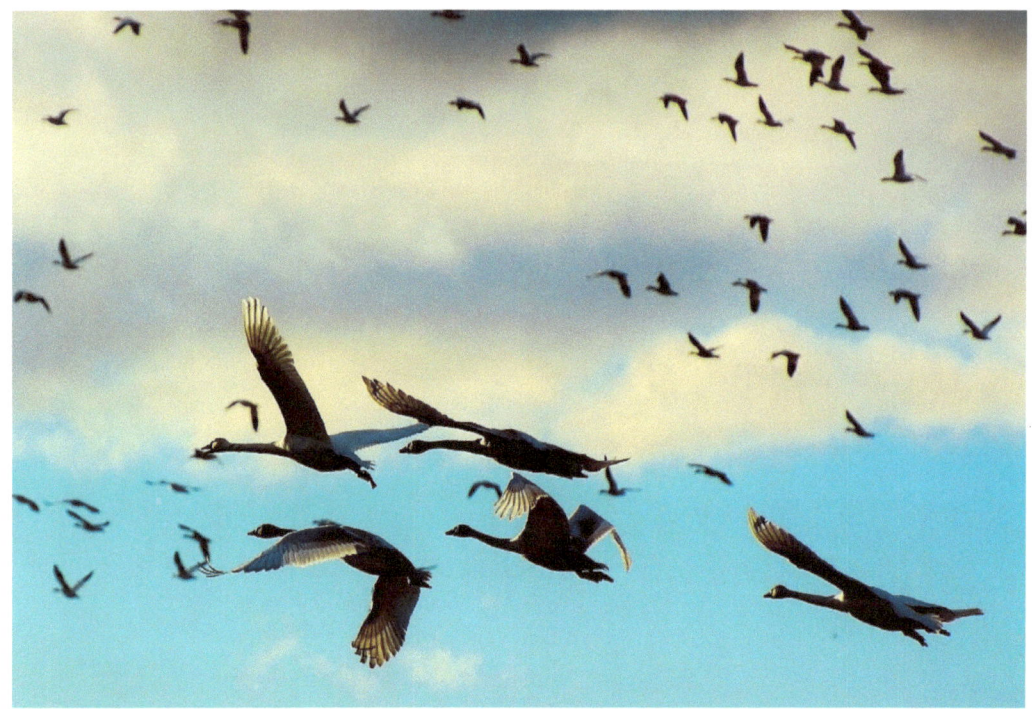

In the background here, you can also see the ducks. I never have to go far from home to find a dramatic scene.

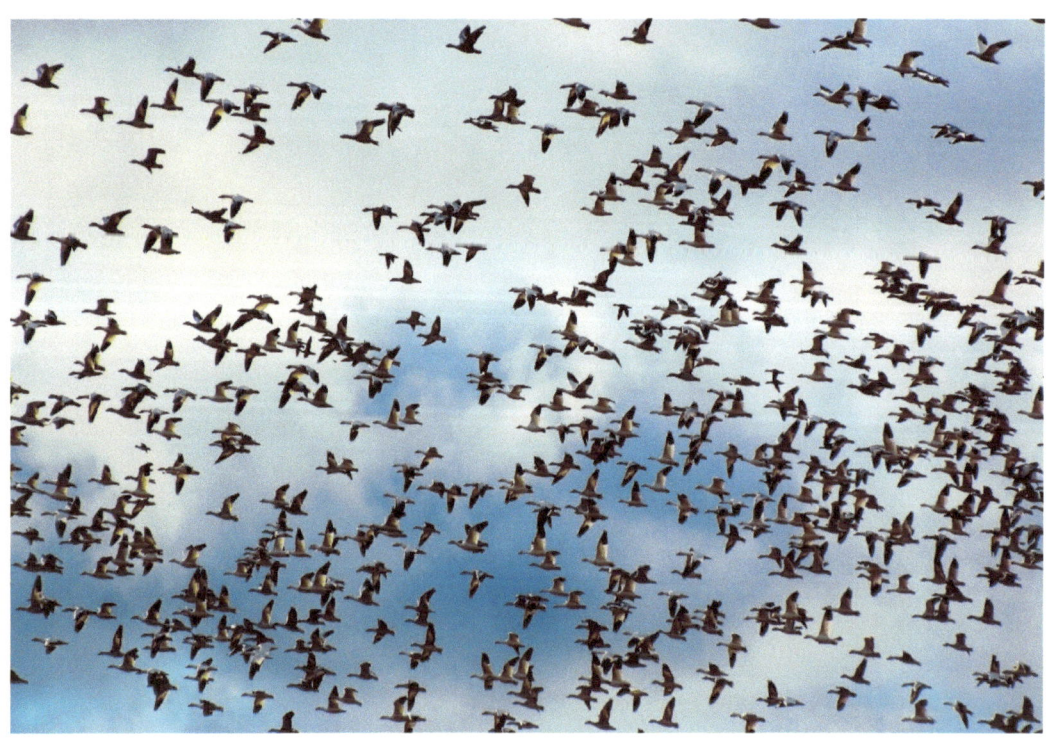

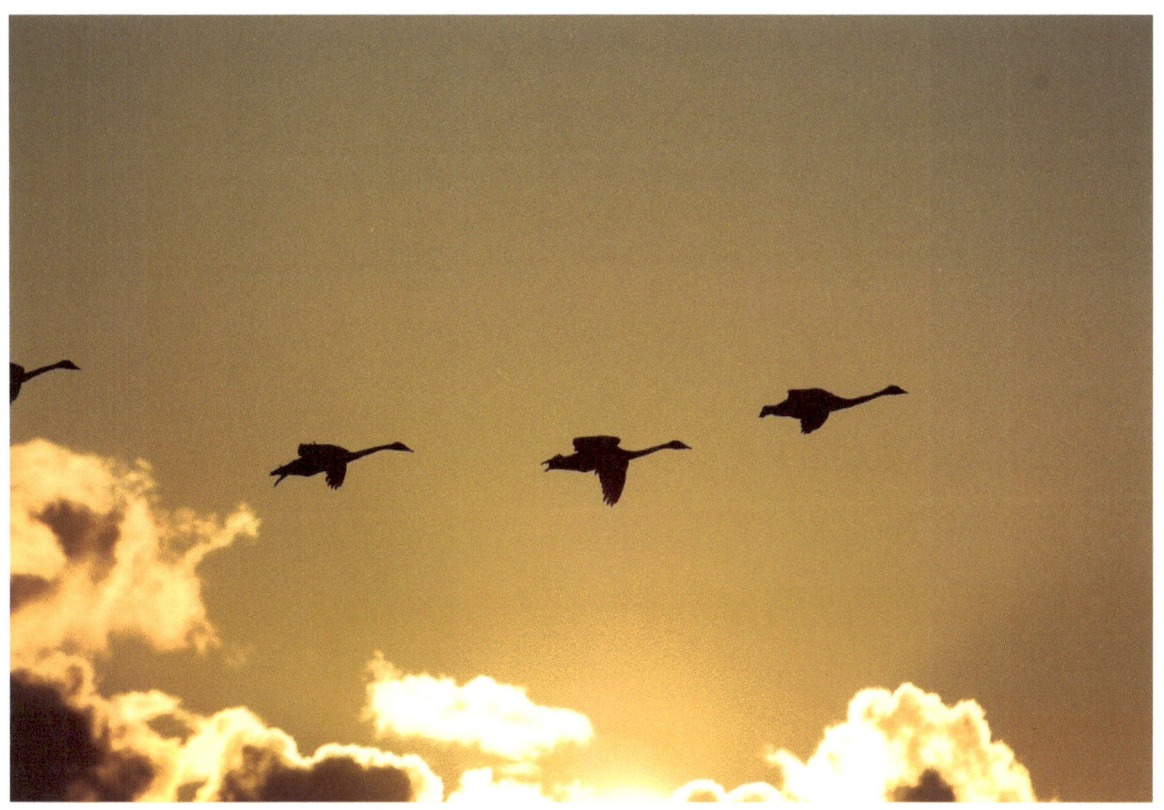

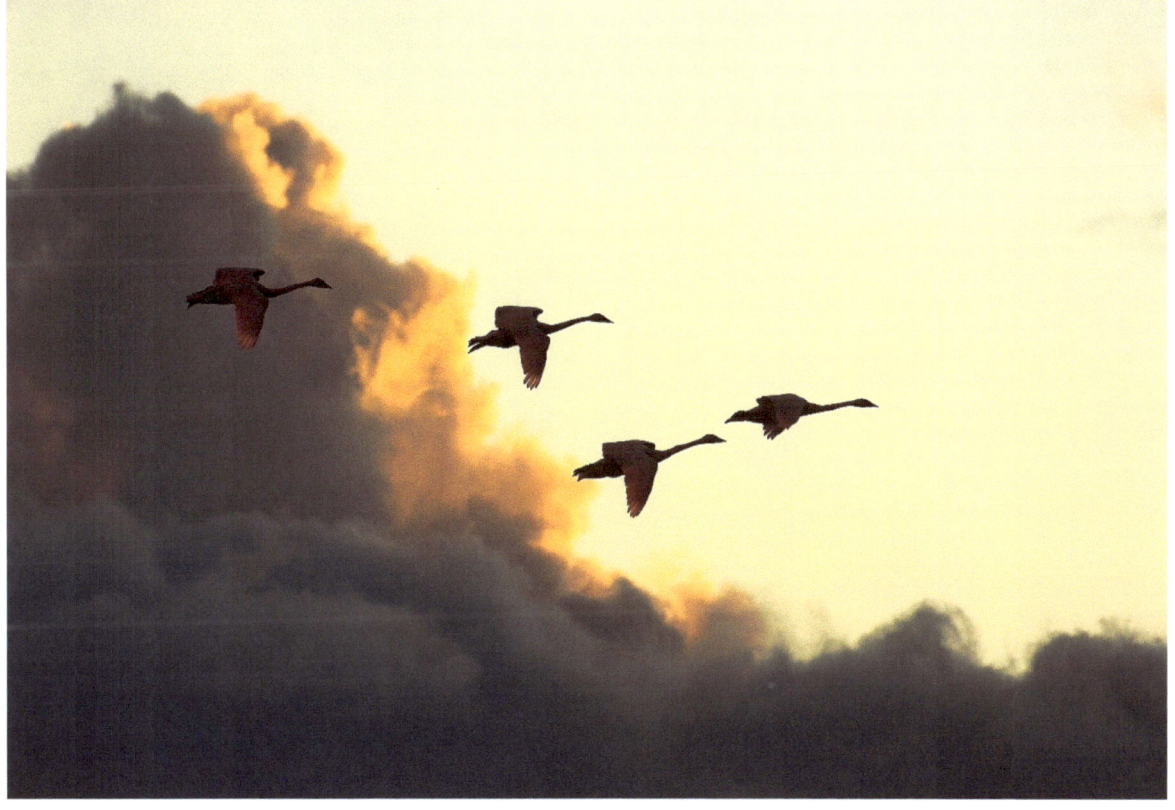

A Great Blue Heron

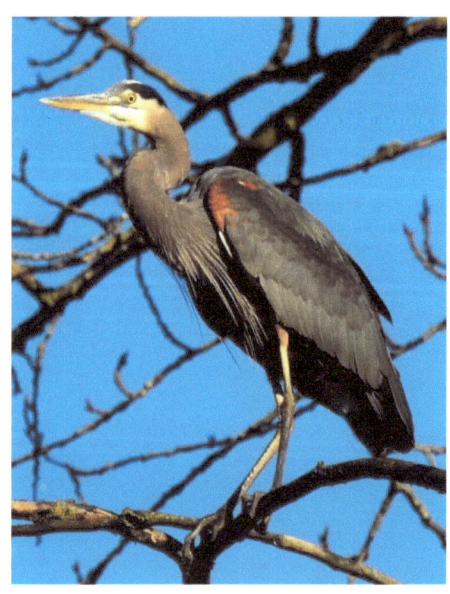

Hart's slough is home to a wide variety of wildlife

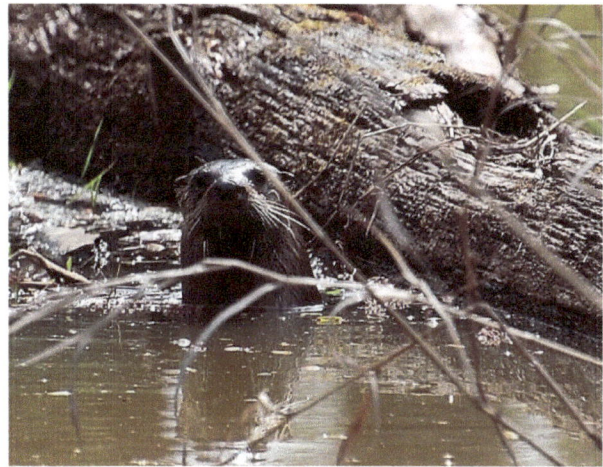

River Otter

Have you ever stopped and really studied an insect before? Some may not consider them 'wildlife', but *I* do! The following are just a few examples.

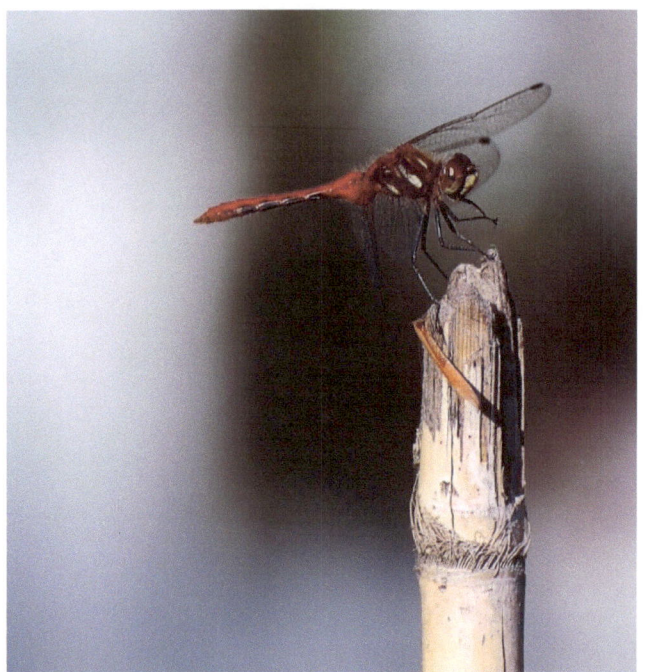

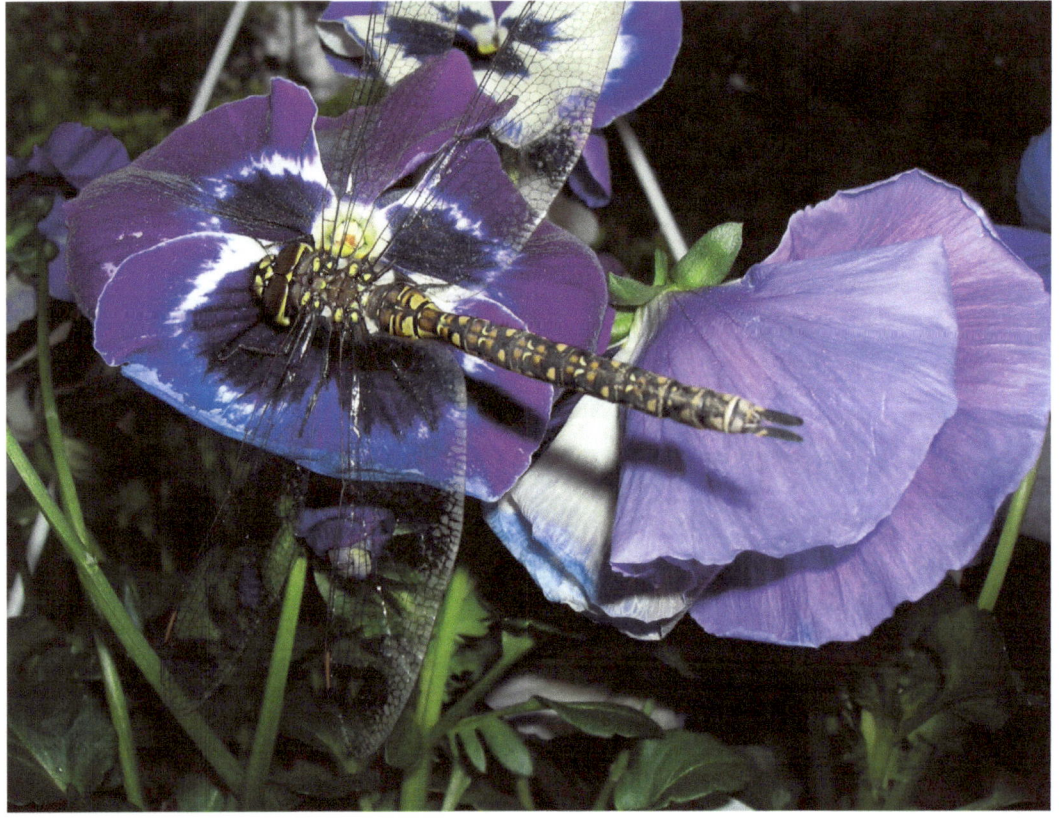

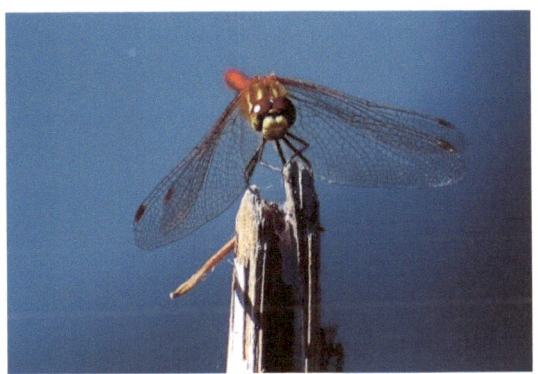

This is called a Giant Moth

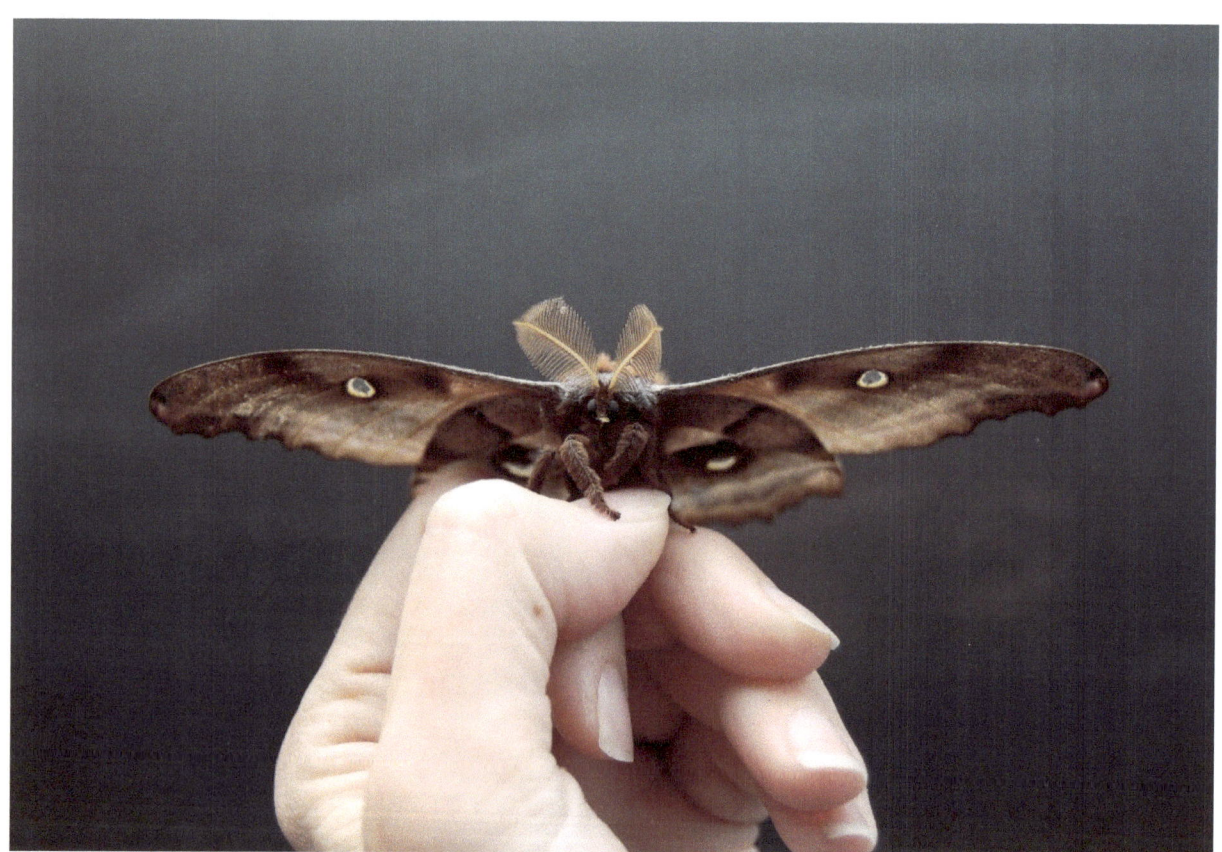

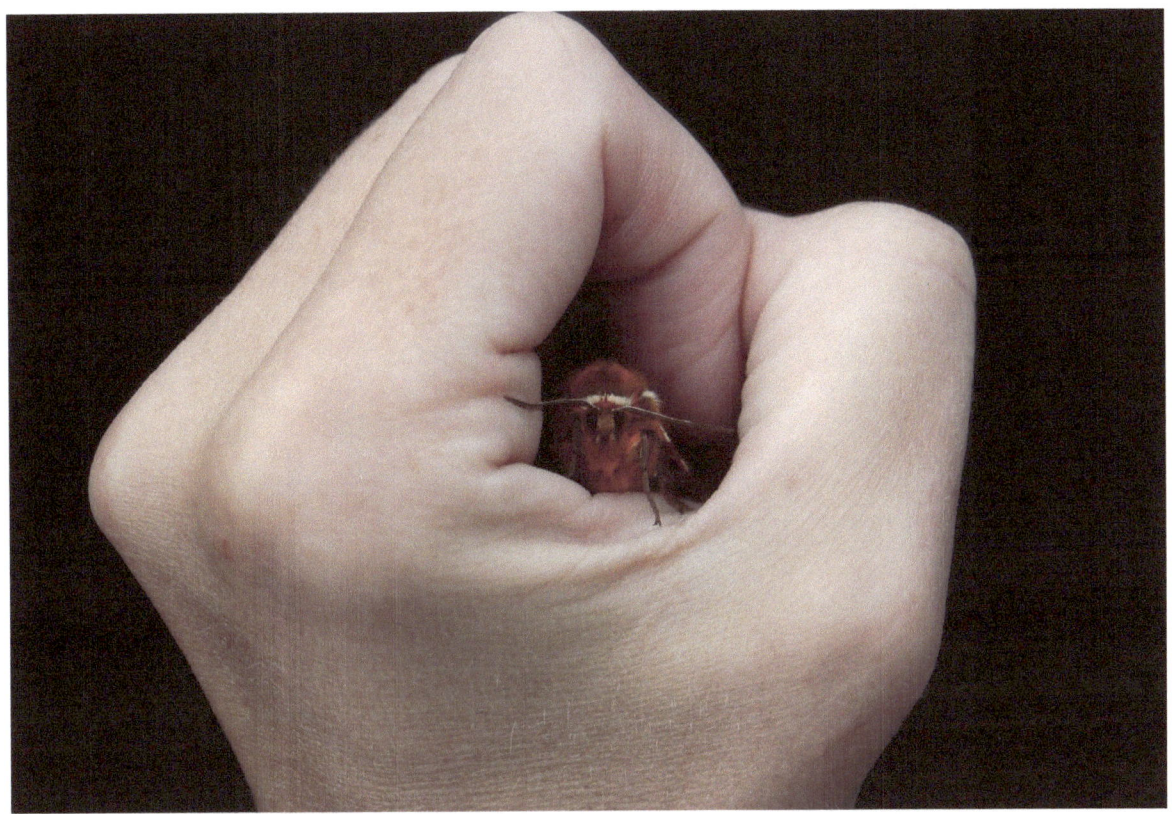

This is a little Tiger Moth

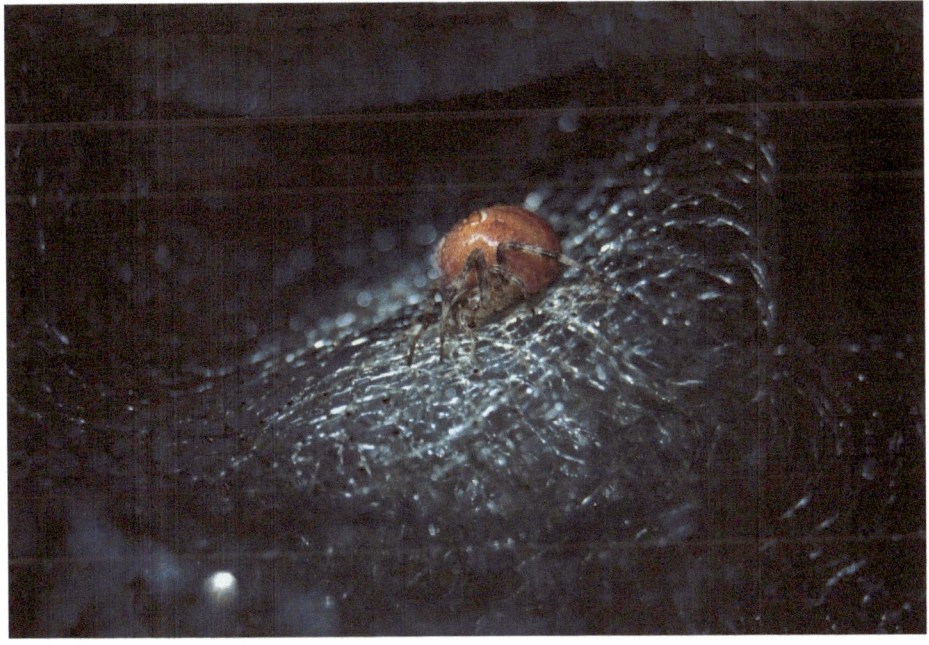

Sorry if you don't like spiders…I don't either, but I thought this was pretty cool.

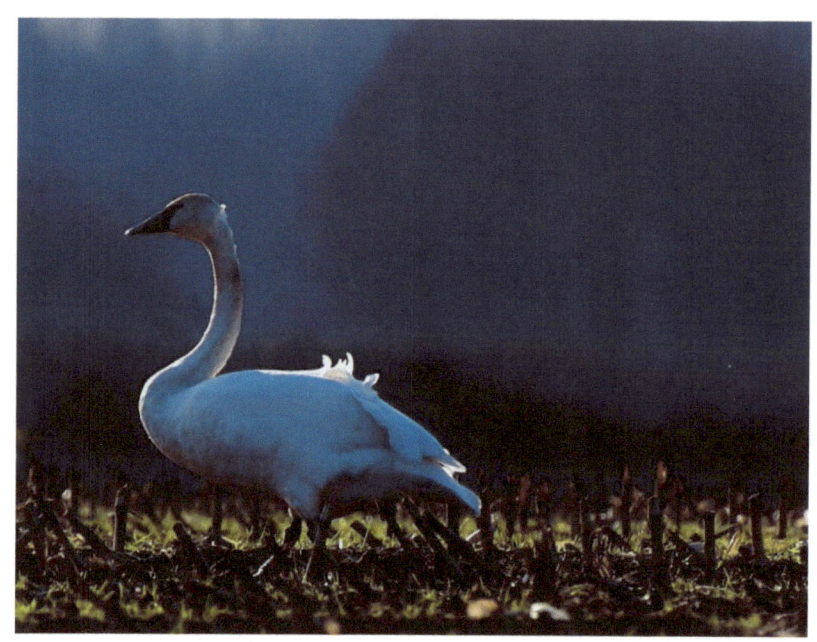

Flowers

*"We need to find God, and he cannot be found in noise and restlessness. God is the friend of silence. See how nature - trees, **flowers**, grass- grows in silence; see the stars, the moon and the sun, how they move in silence... We need silence to be able to touch souls."*
-Mother Teresa

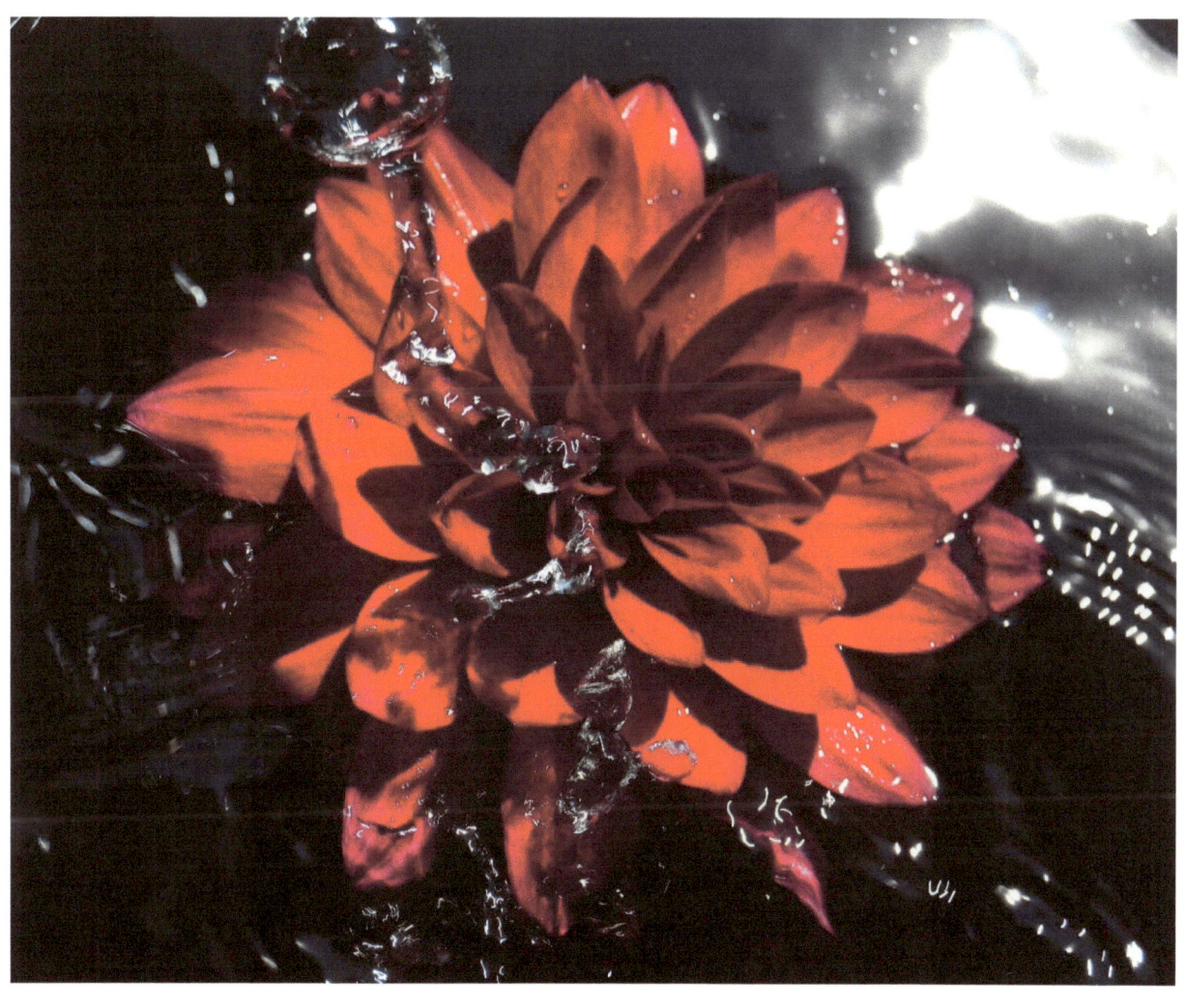

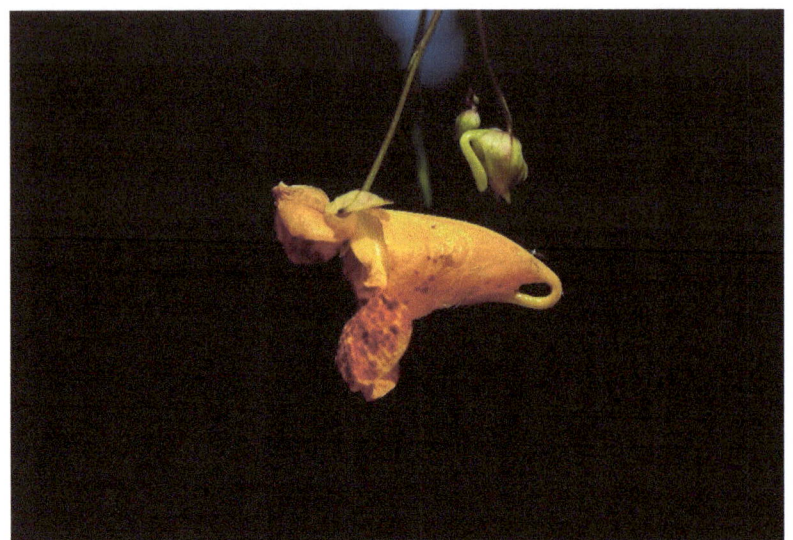
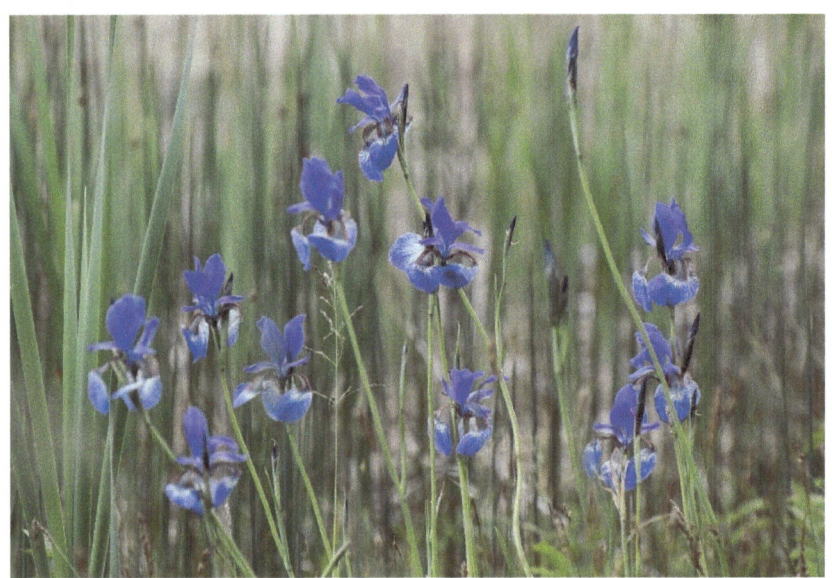
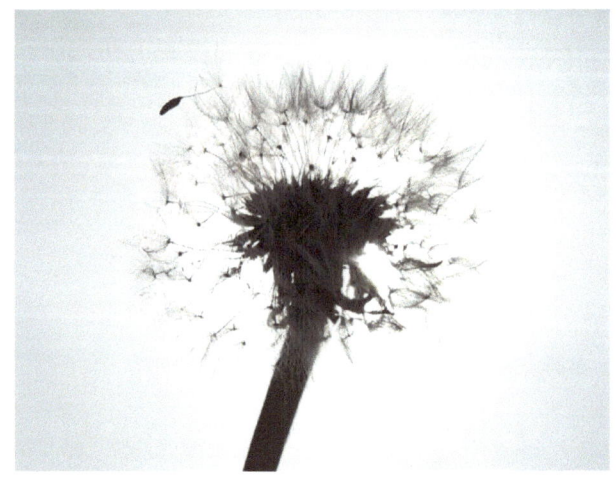

NATURE'S TAPESTRY

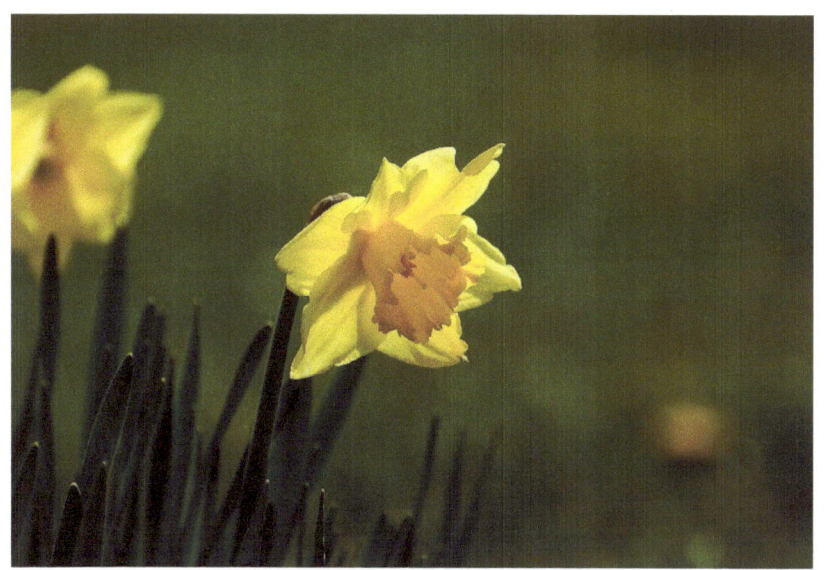

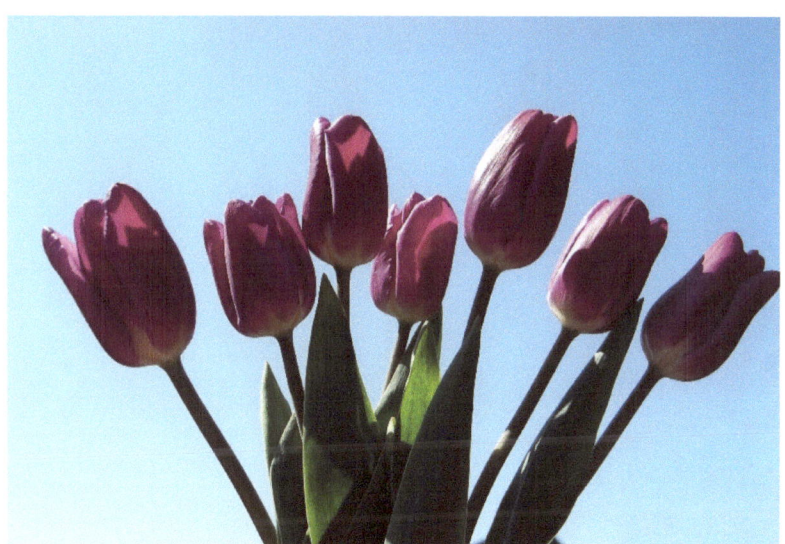

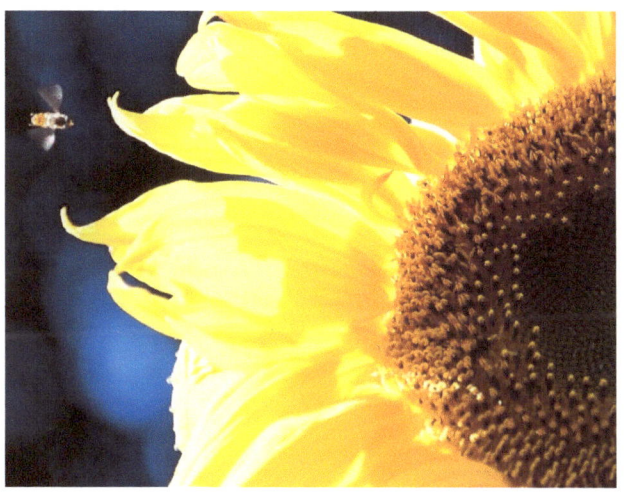

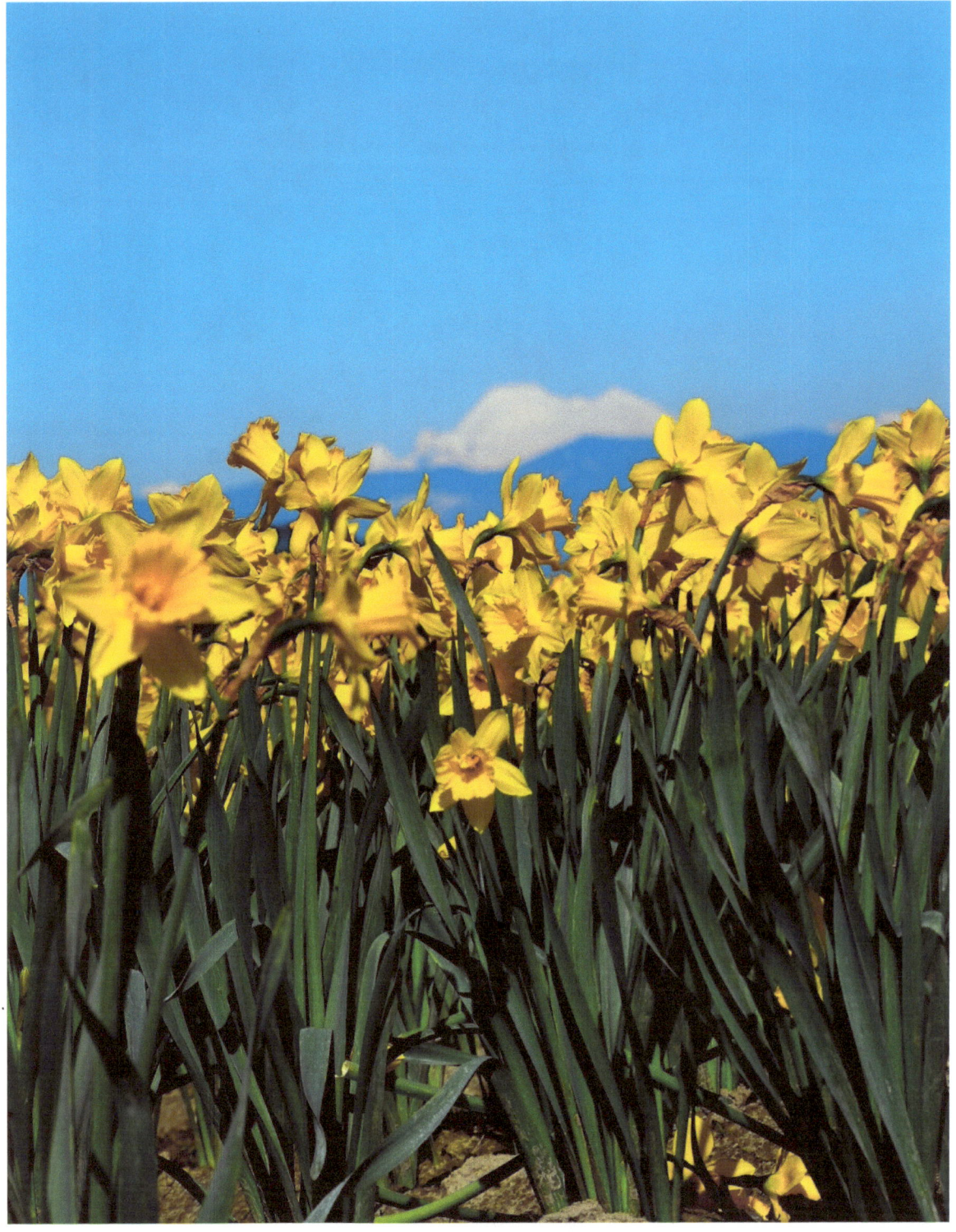

Skagit Valley, Washington is world famous for its fields of tulips and daffodils. (Mount Baker can be seen in the background)

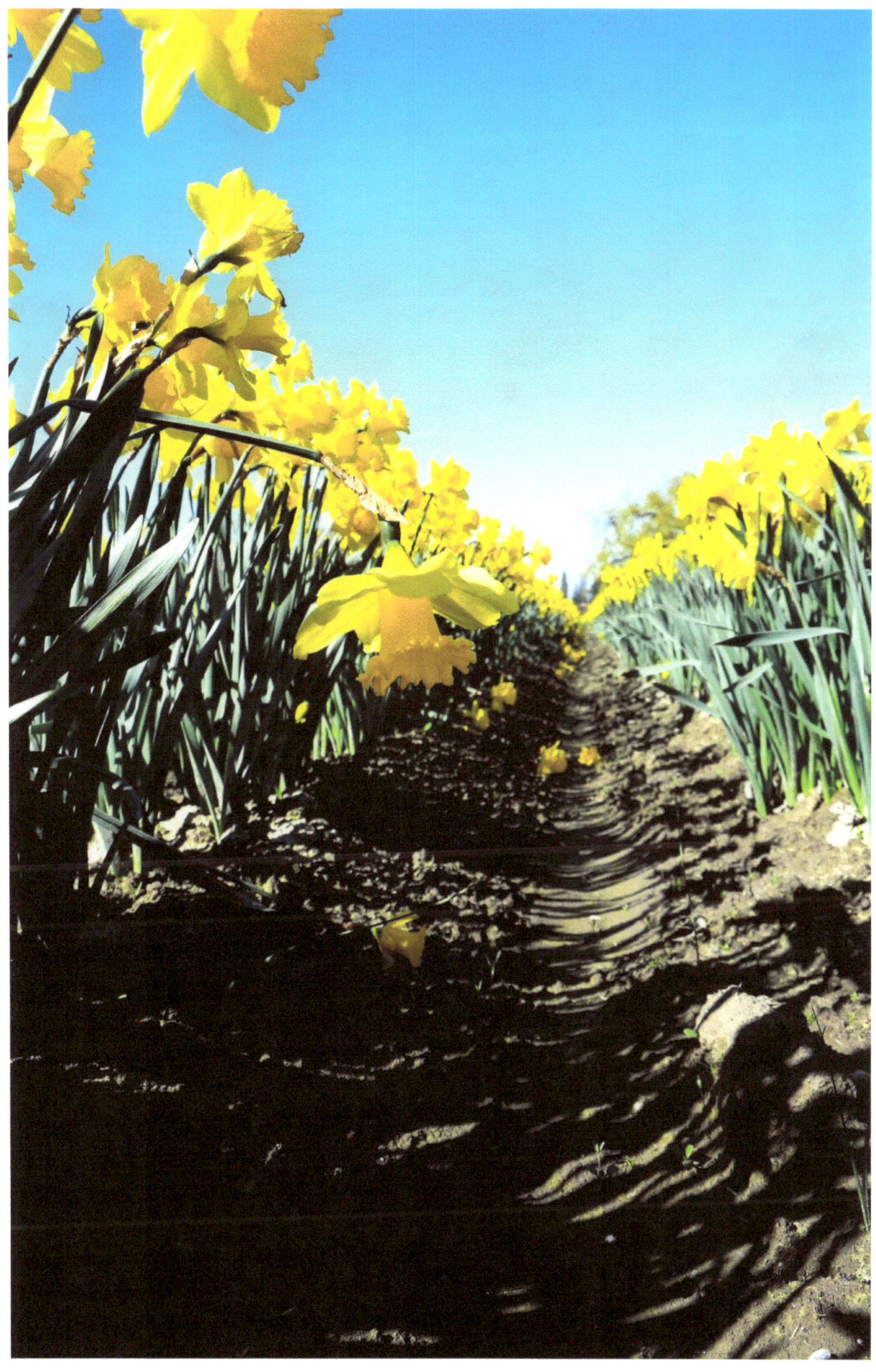

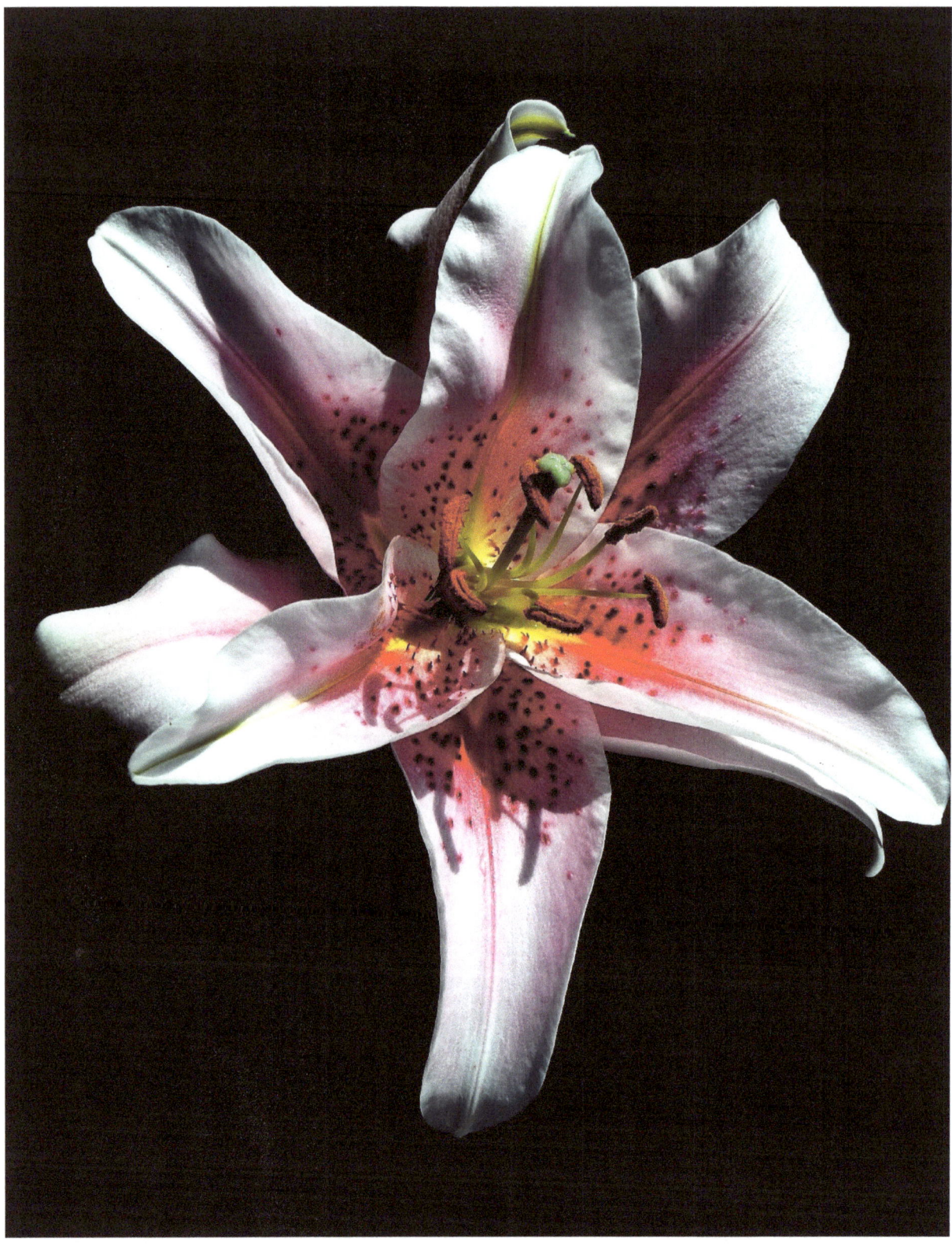

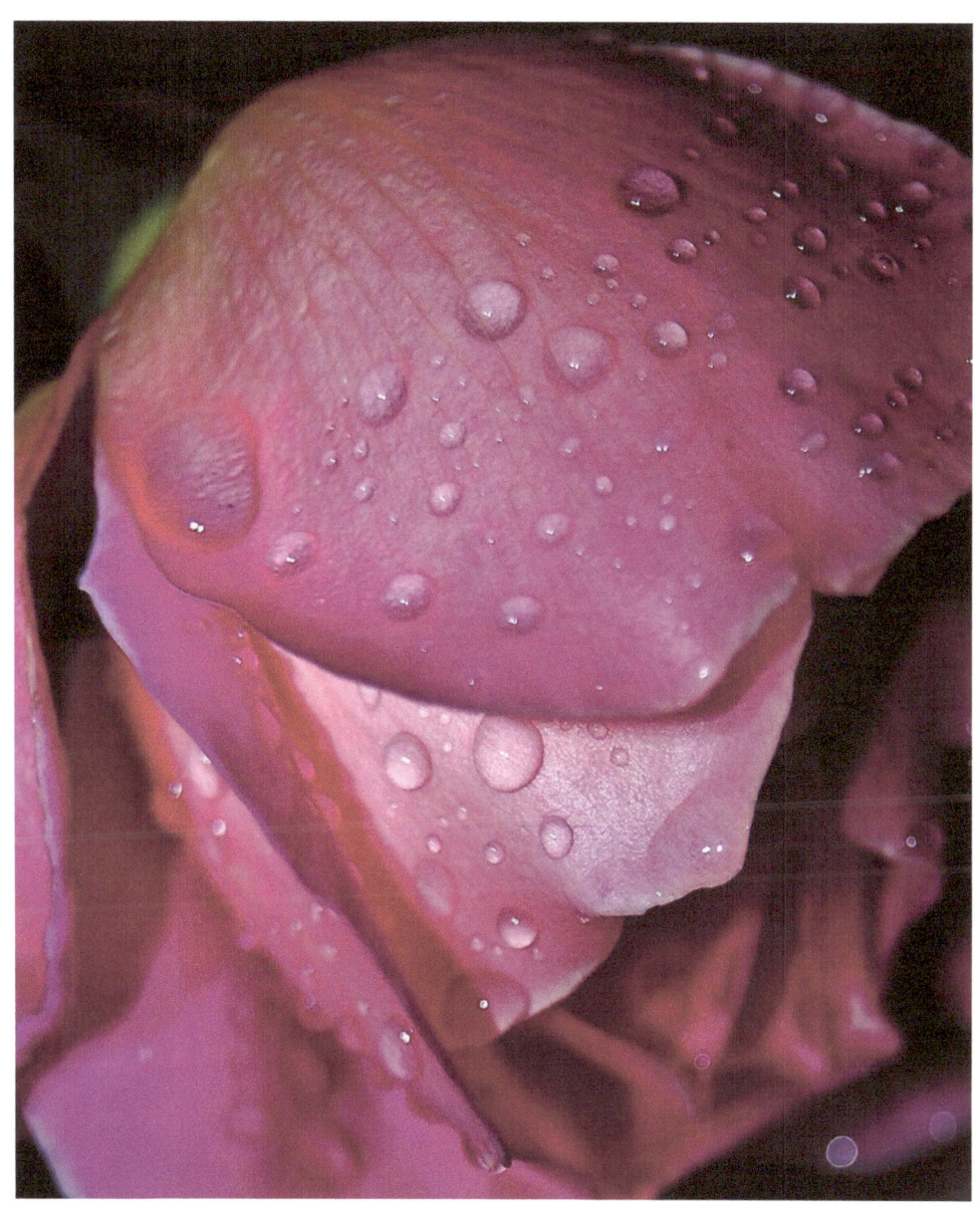

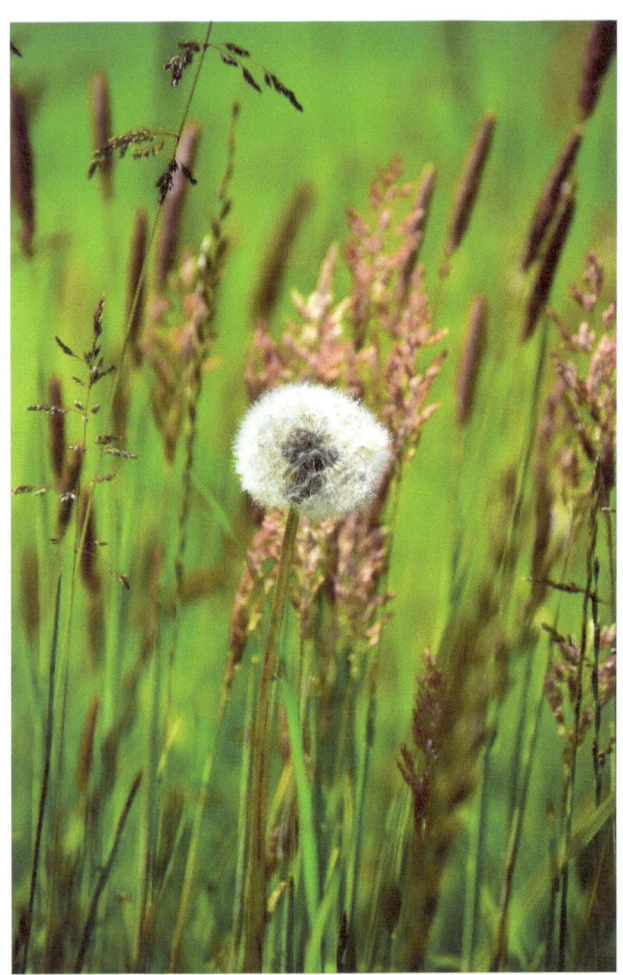

I never get tired of photographing flowers (or even weeds…as you can see by the dandelion above). Their vibrant colors, perfect symmetry and wonderful scents draw me in.

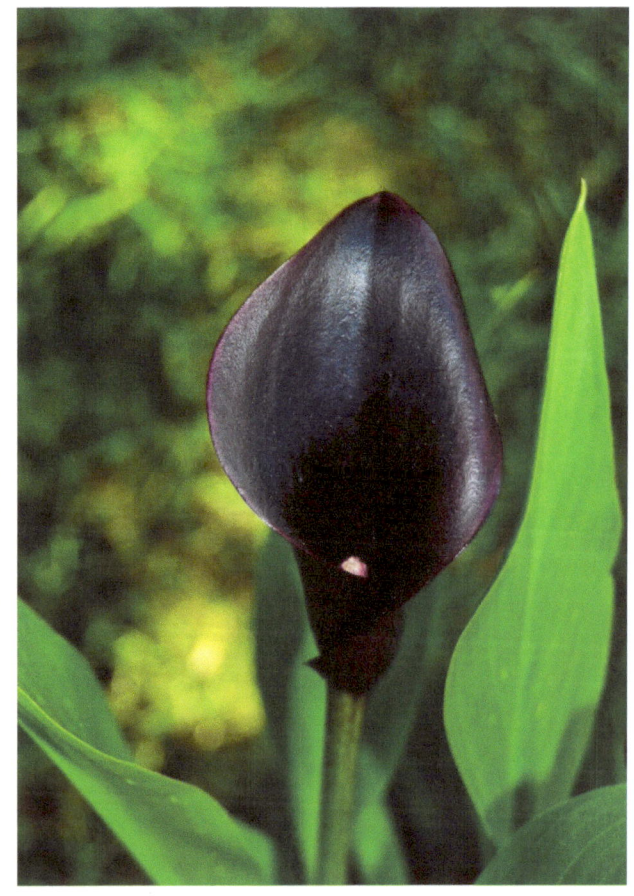

Silhouette

"Keep your face always toward the sunshine - and shadows will fall behind you."
-Walt Whitman

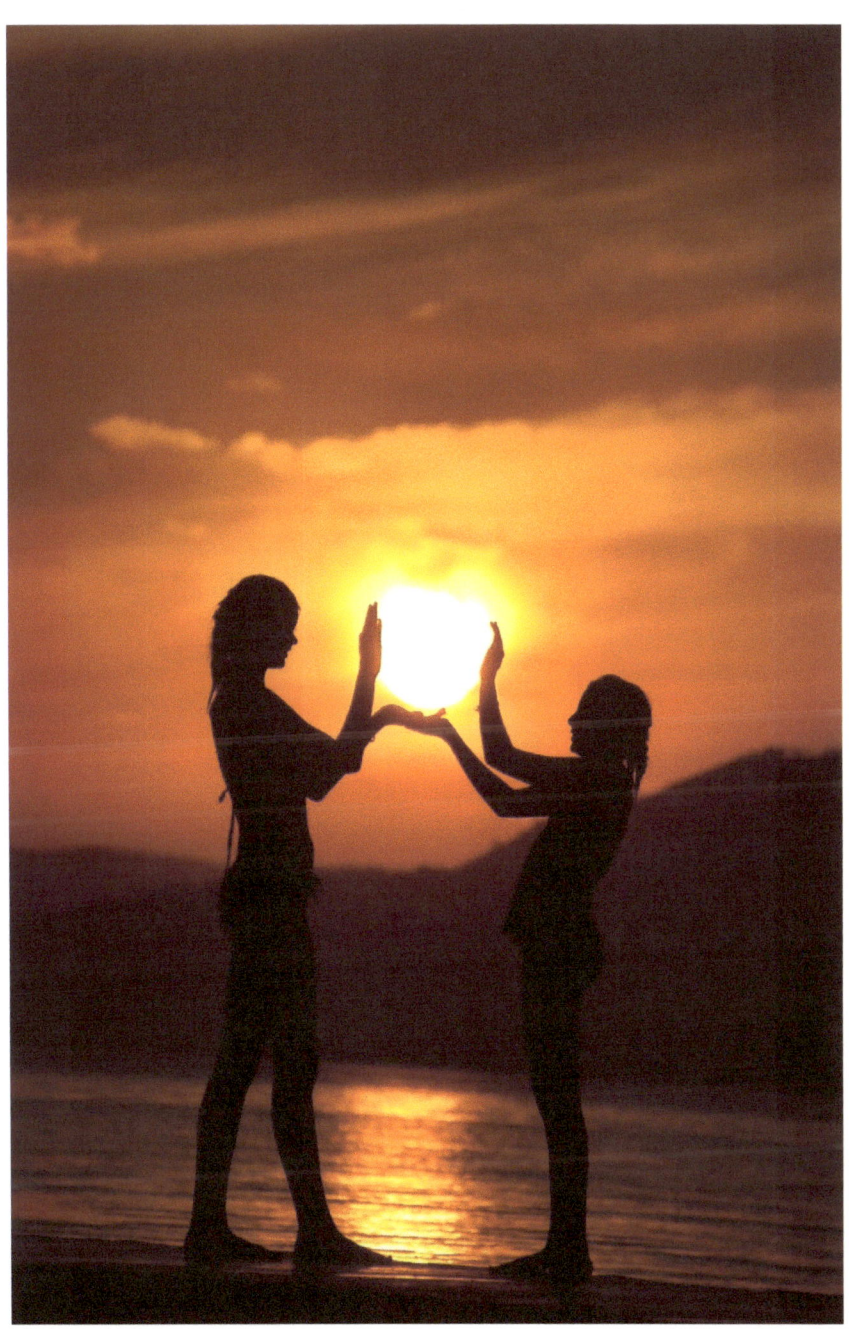

There is something about a silhouette that turns a scene from ordinary, to magical and mysterious. There is a dance between shadows and light, and finding that space in between is a fun challenge that I seek out.

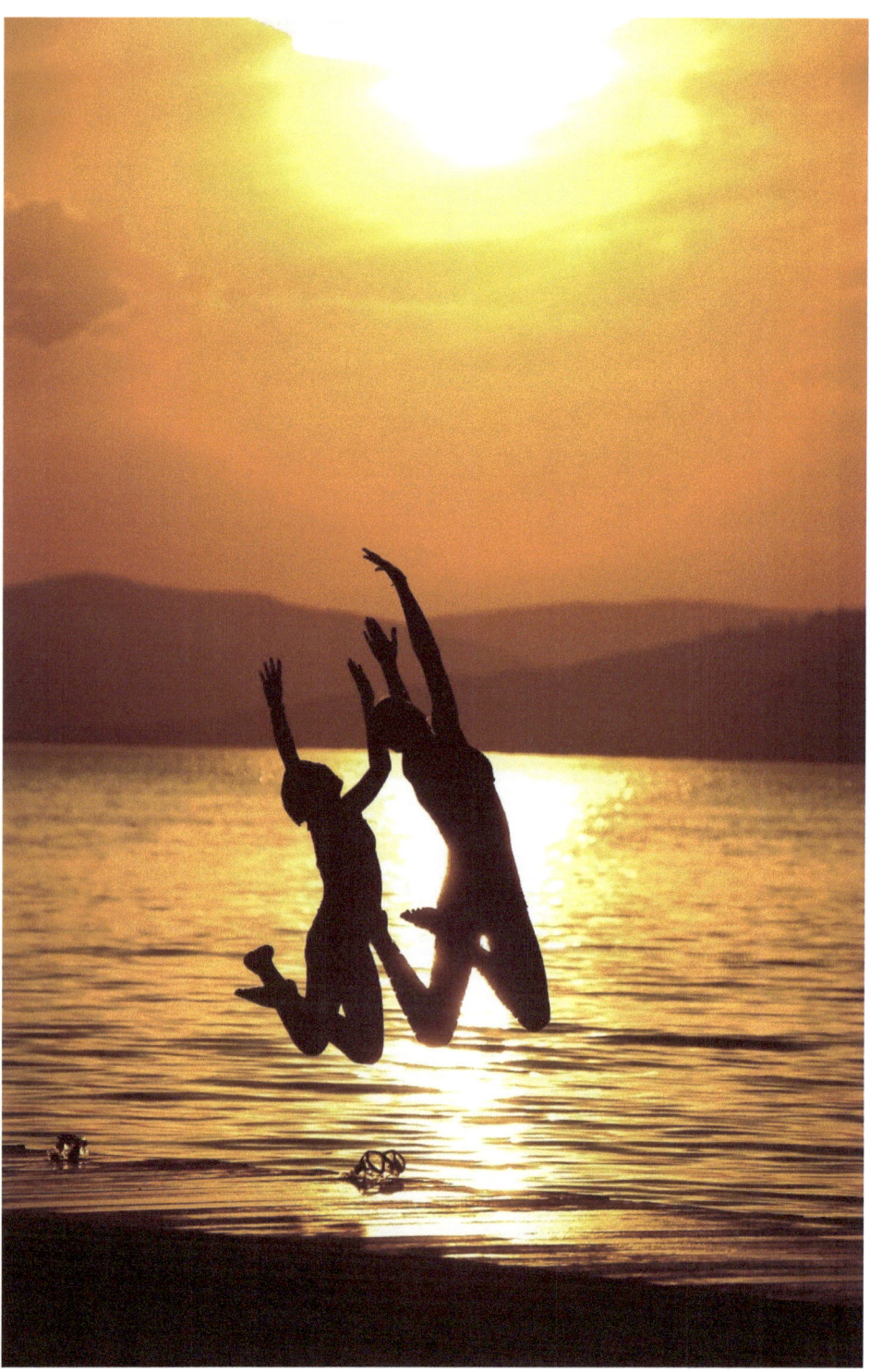

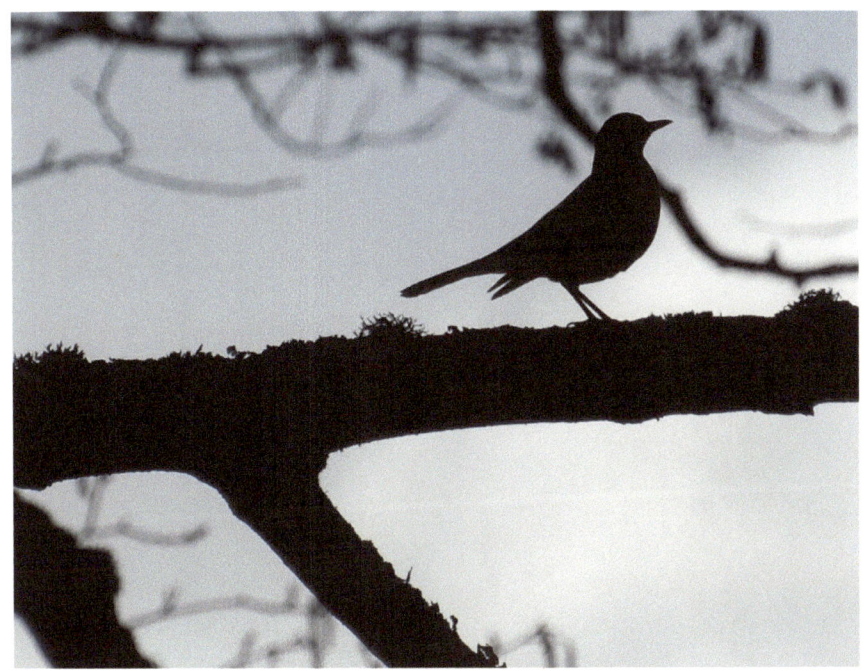

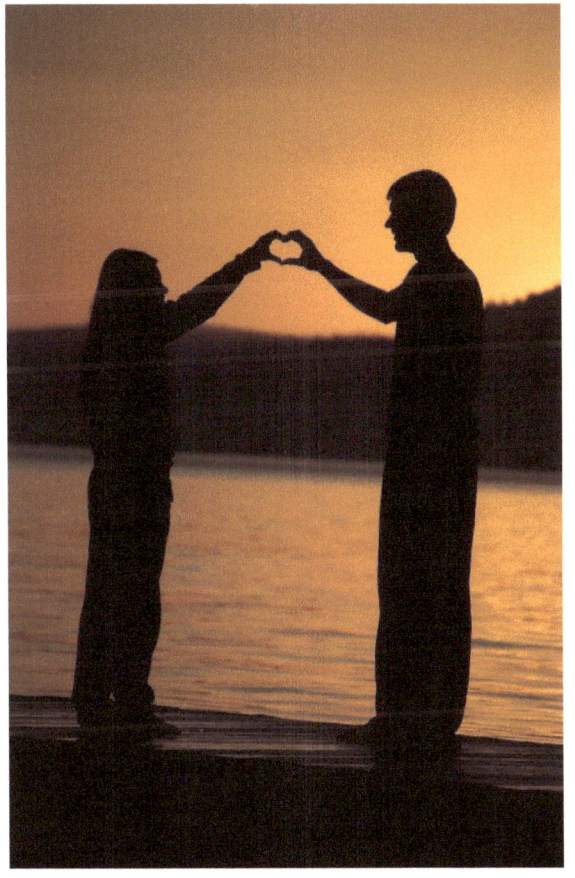

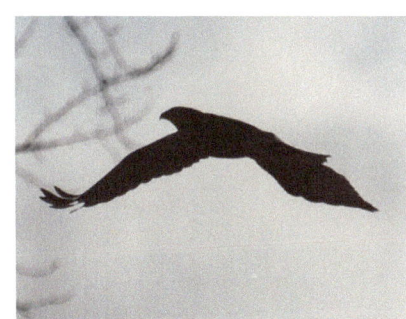

"There are dark shadows on the earth, but its lights are stronger in the contrast."
-Charles Dickens

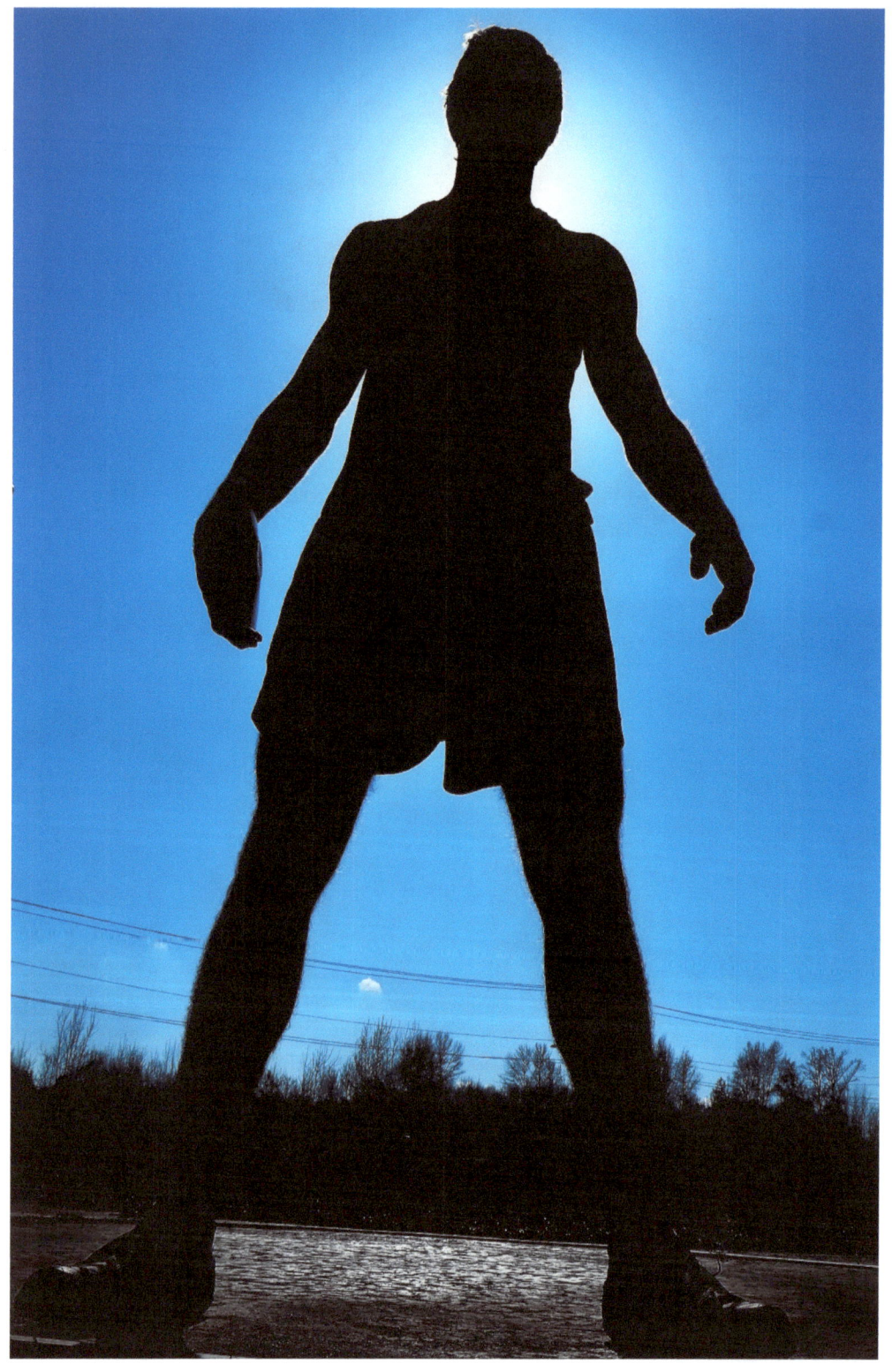

Sky

*"It's wonderful to climb the liquid mountains of the **sky**. Behind me and before me is God and I have no fears."*
-Helen Keller

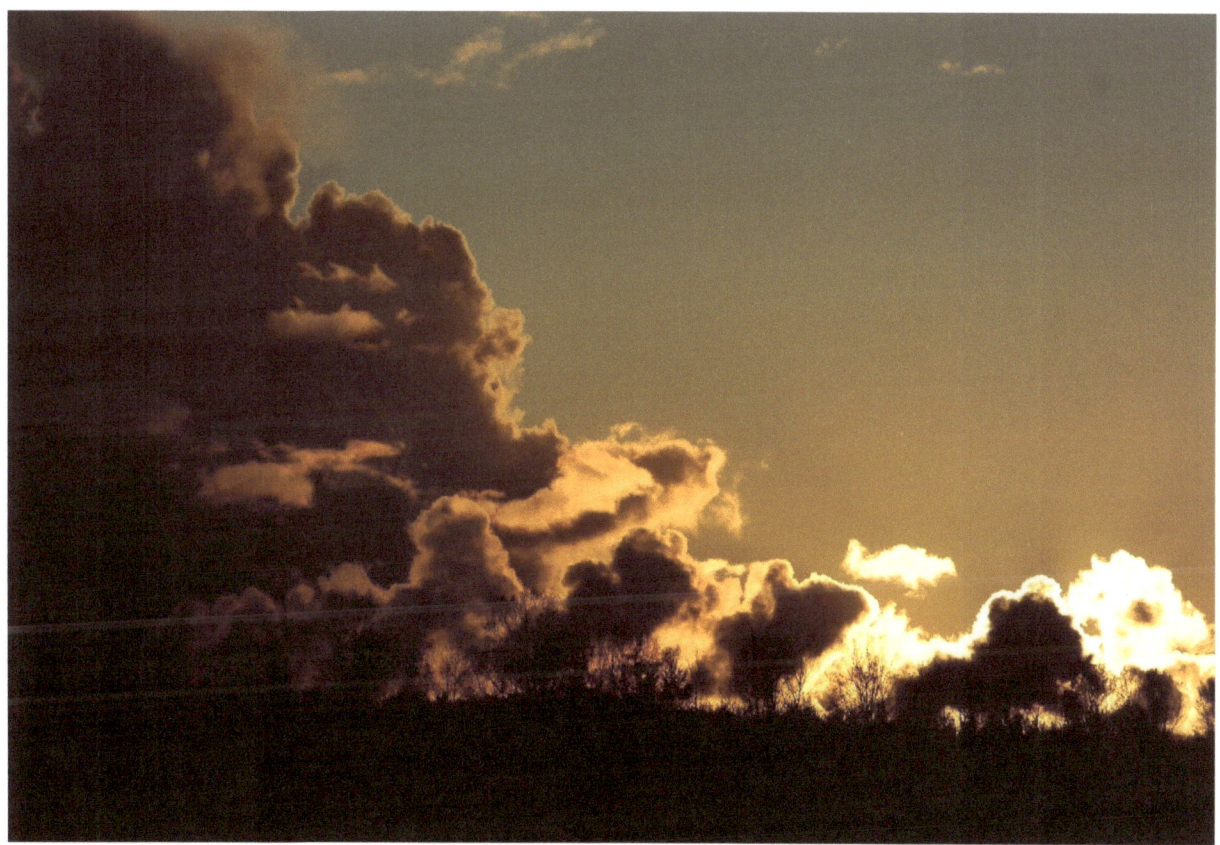

The following images are a combination of sunsets, clouds, the moon and some of my favorite halos and rainbows. The sky fascinates me. Do you look up very often? I find myself staring up at the sky all the time now. I didn't use to, and I can't help but wonder what I have missed over the years.

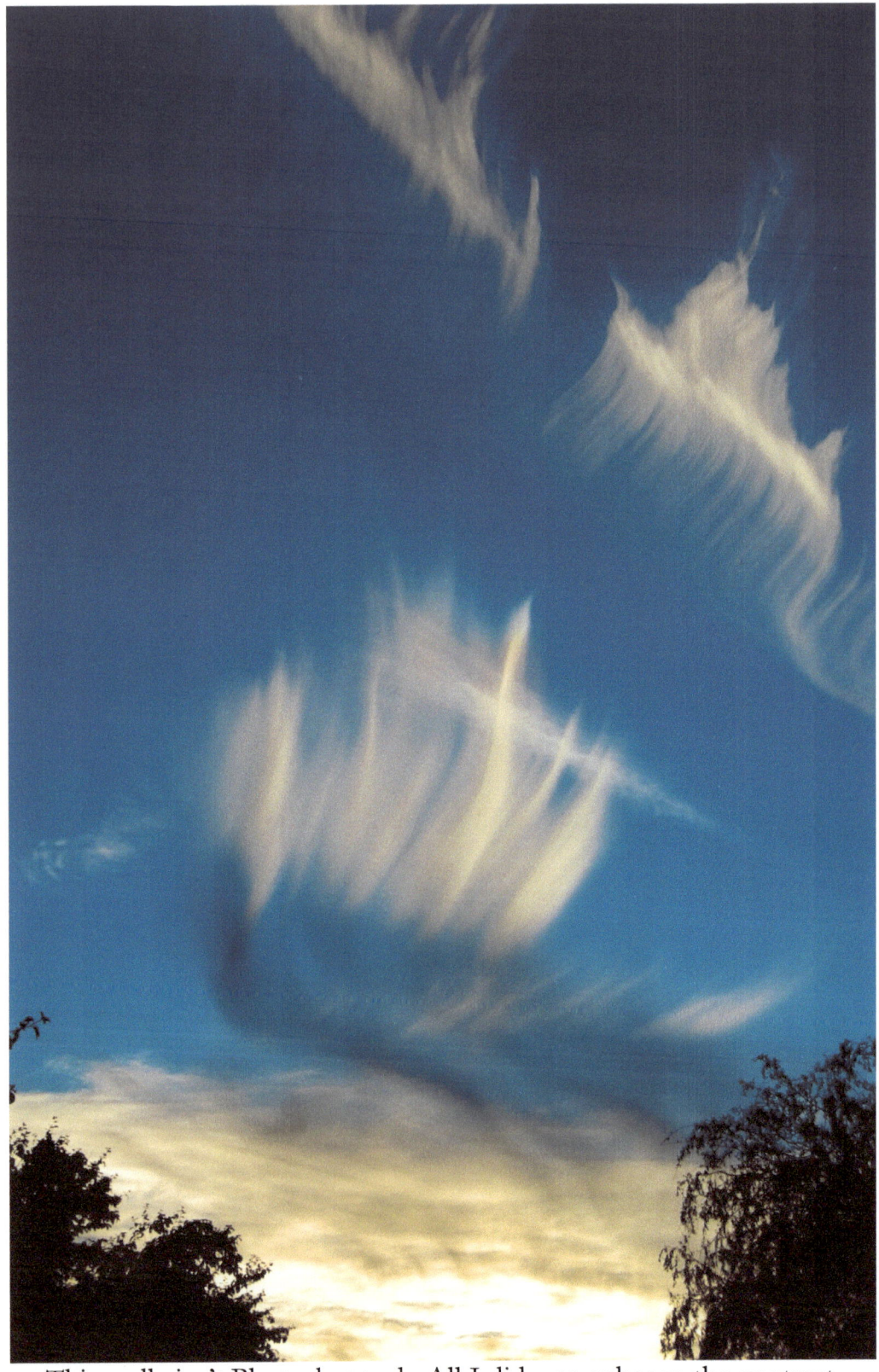

This really isn't Photoshopped. All I did was enhance the contrast.

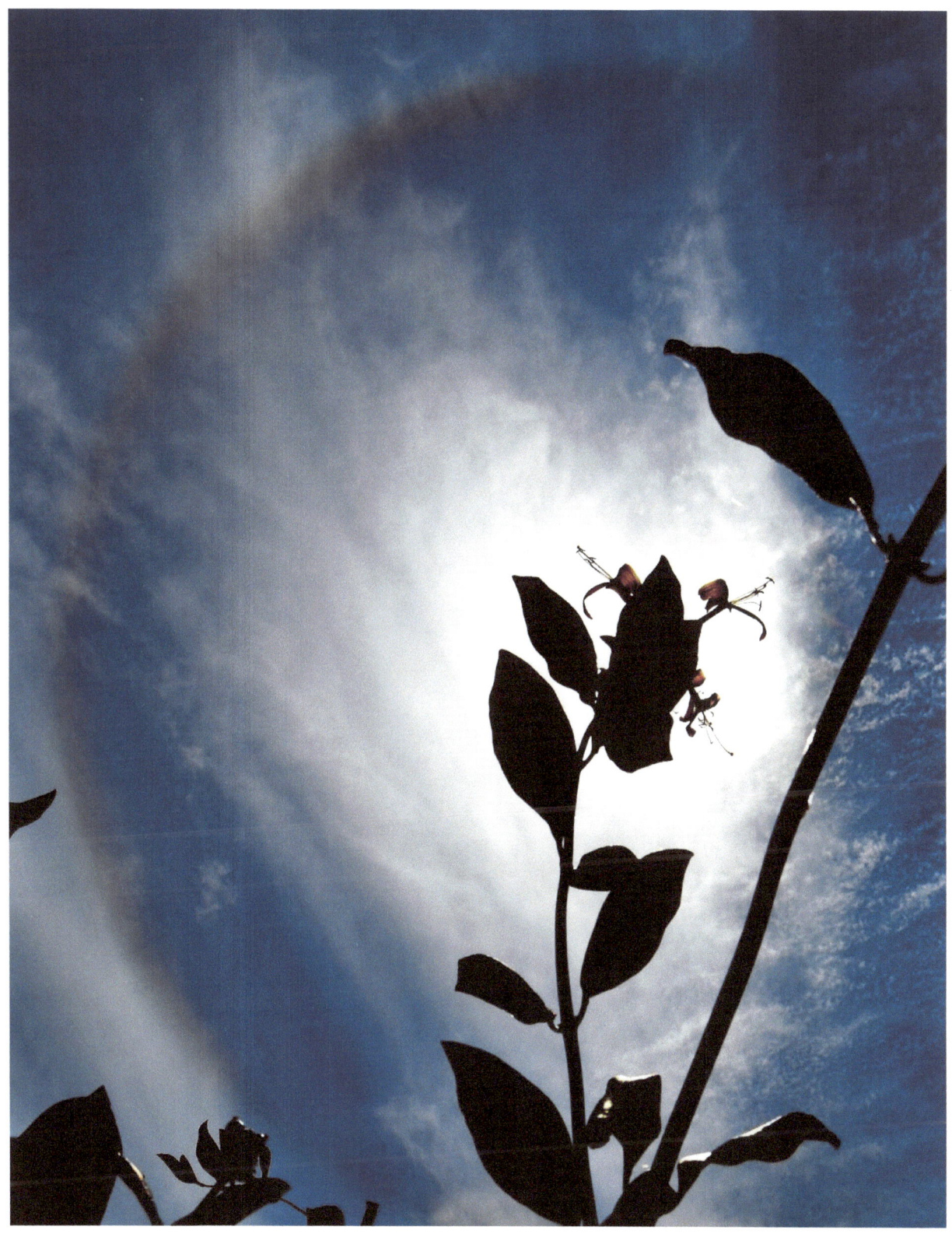

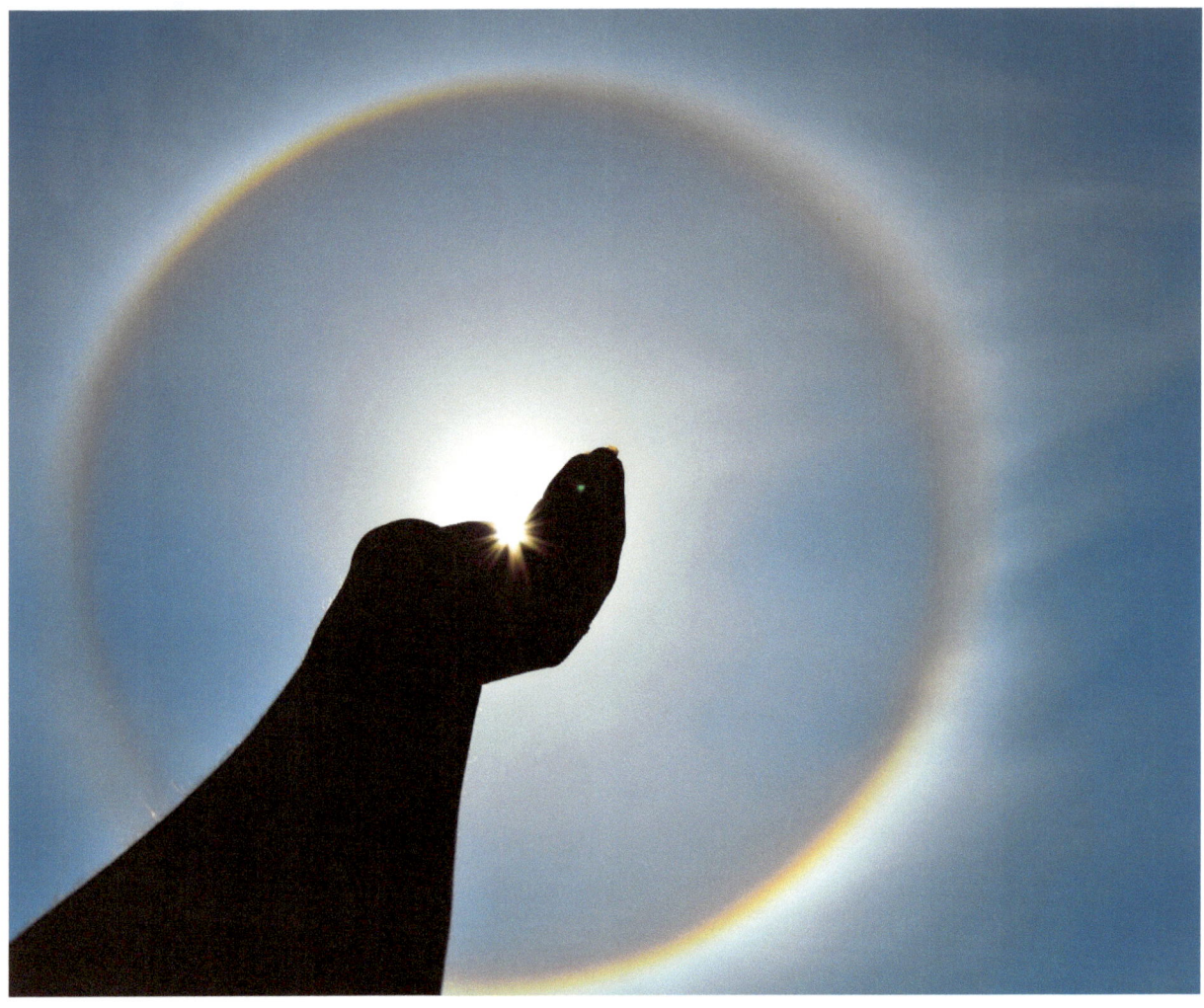

Sun halos are a phenomenon that are caused by the sunlight reflecting off of ice crystals high up in the atmosphere. They only occur under precise circumstances, which is why you don't see them that often.

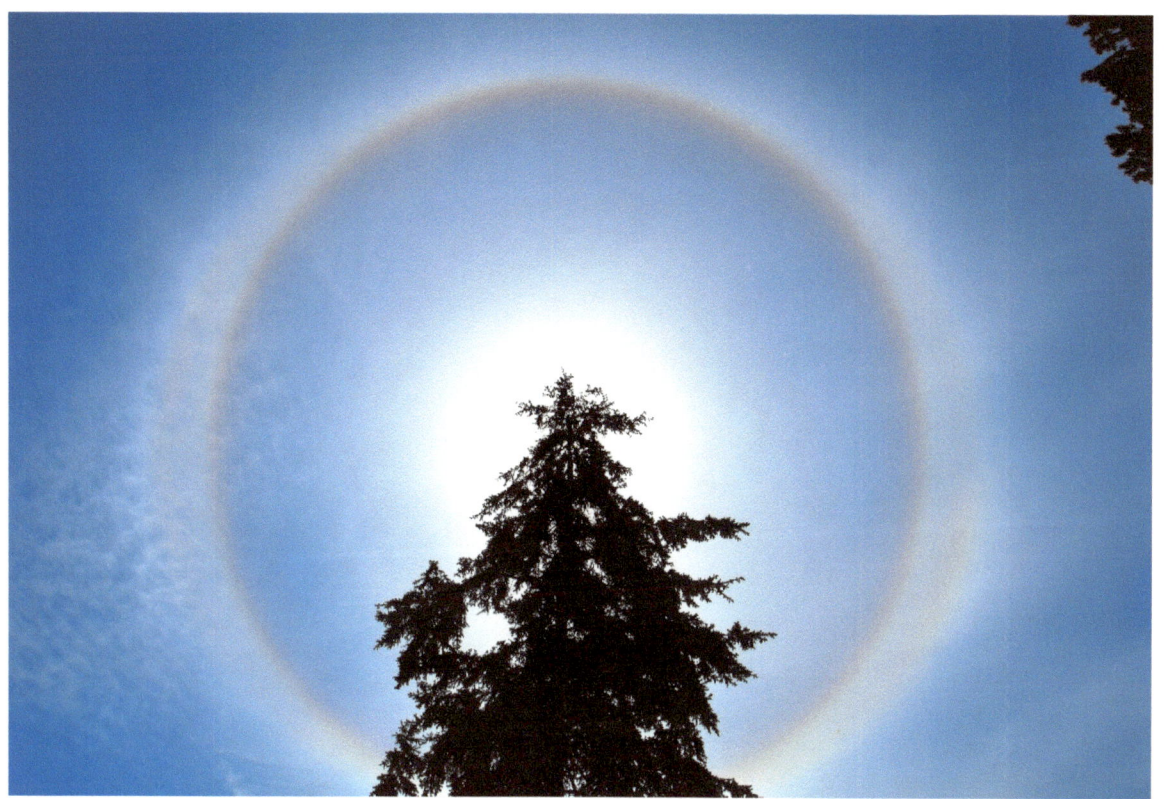

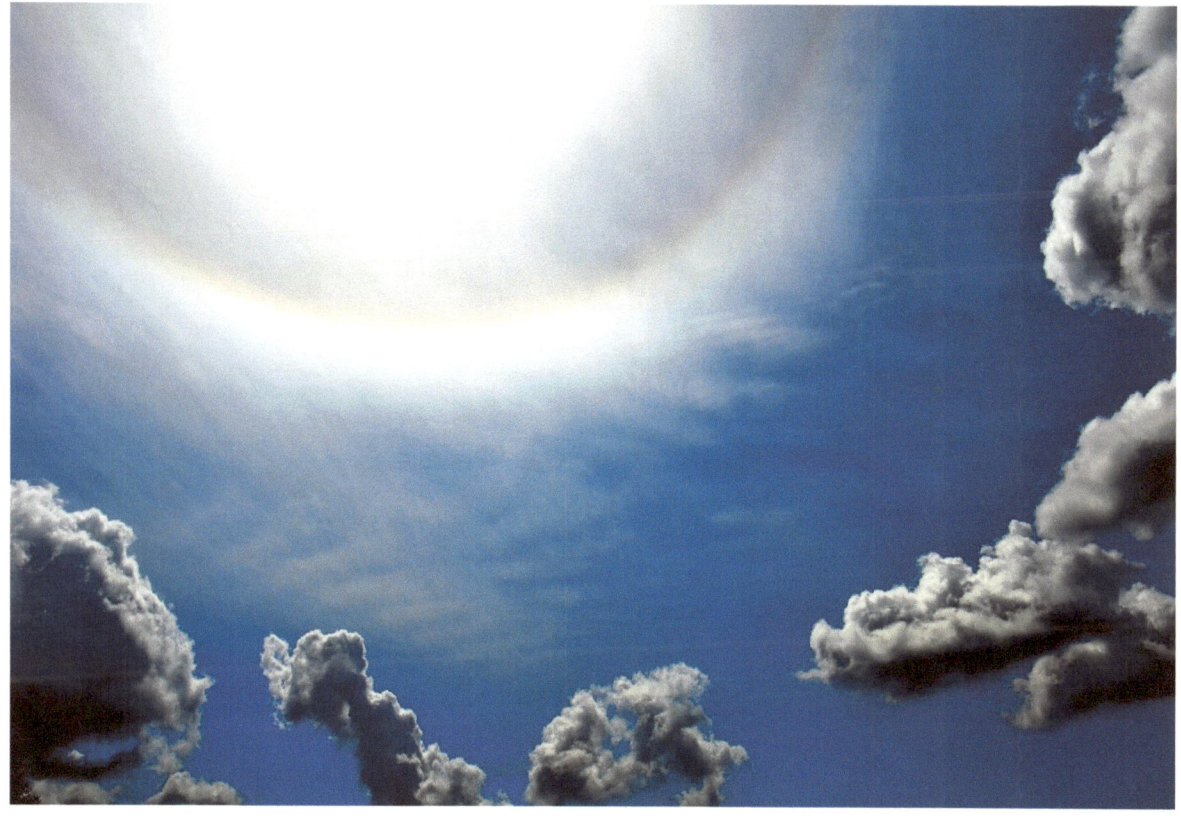

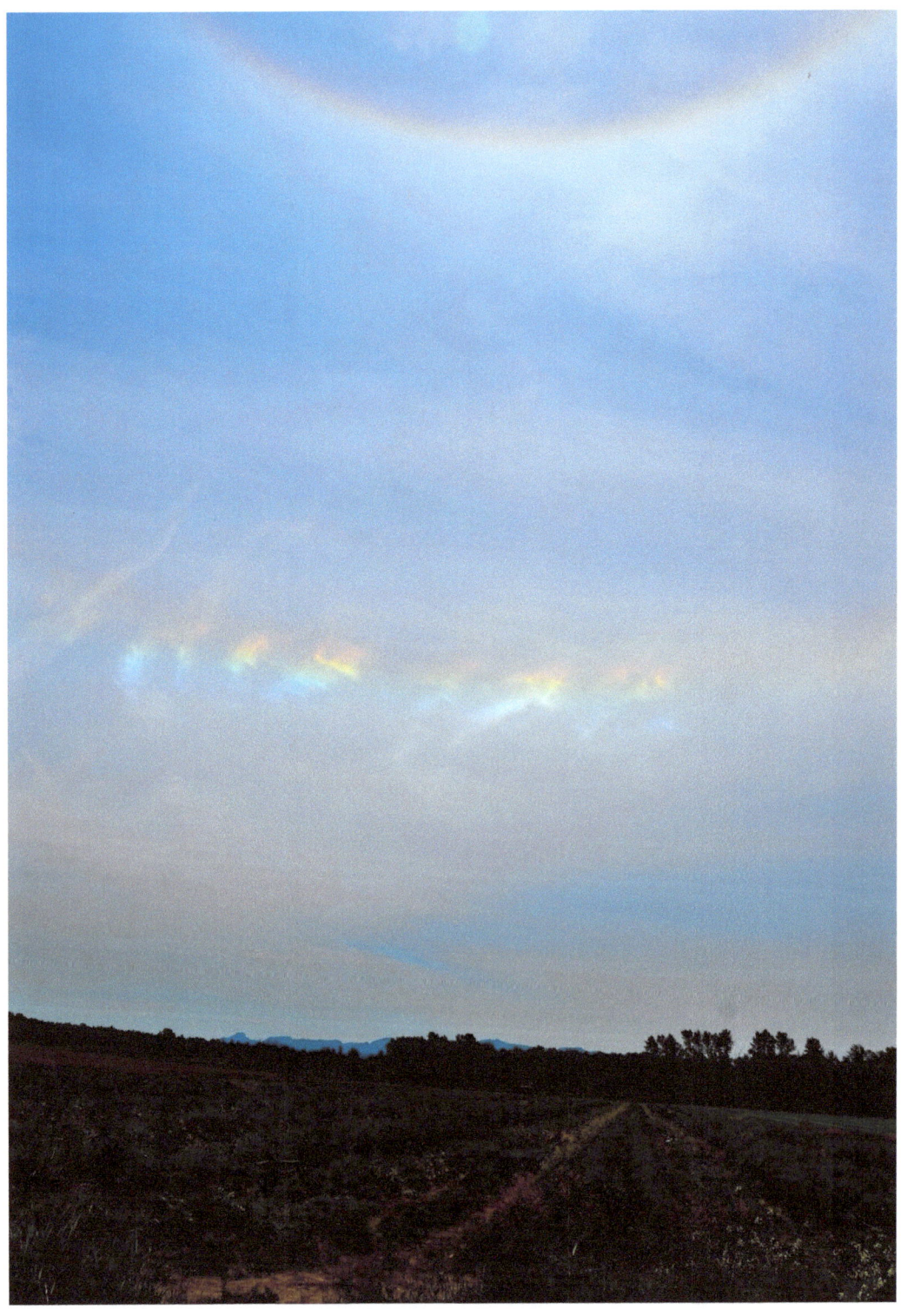

Shown here is a rare fire rainbow, under a sun halo

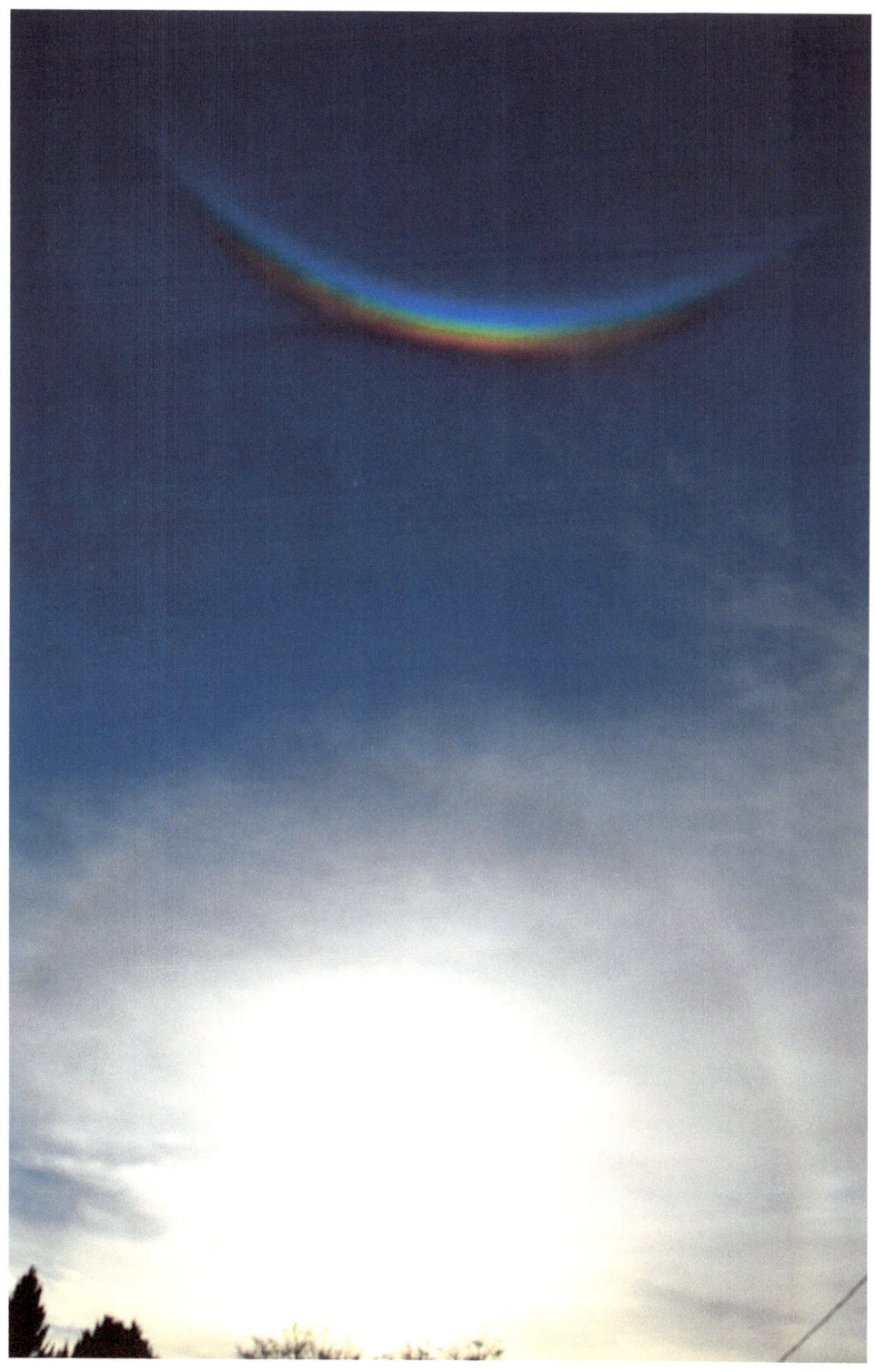

This is a circumzenithal arc, otherwise known as an upside down rainbow

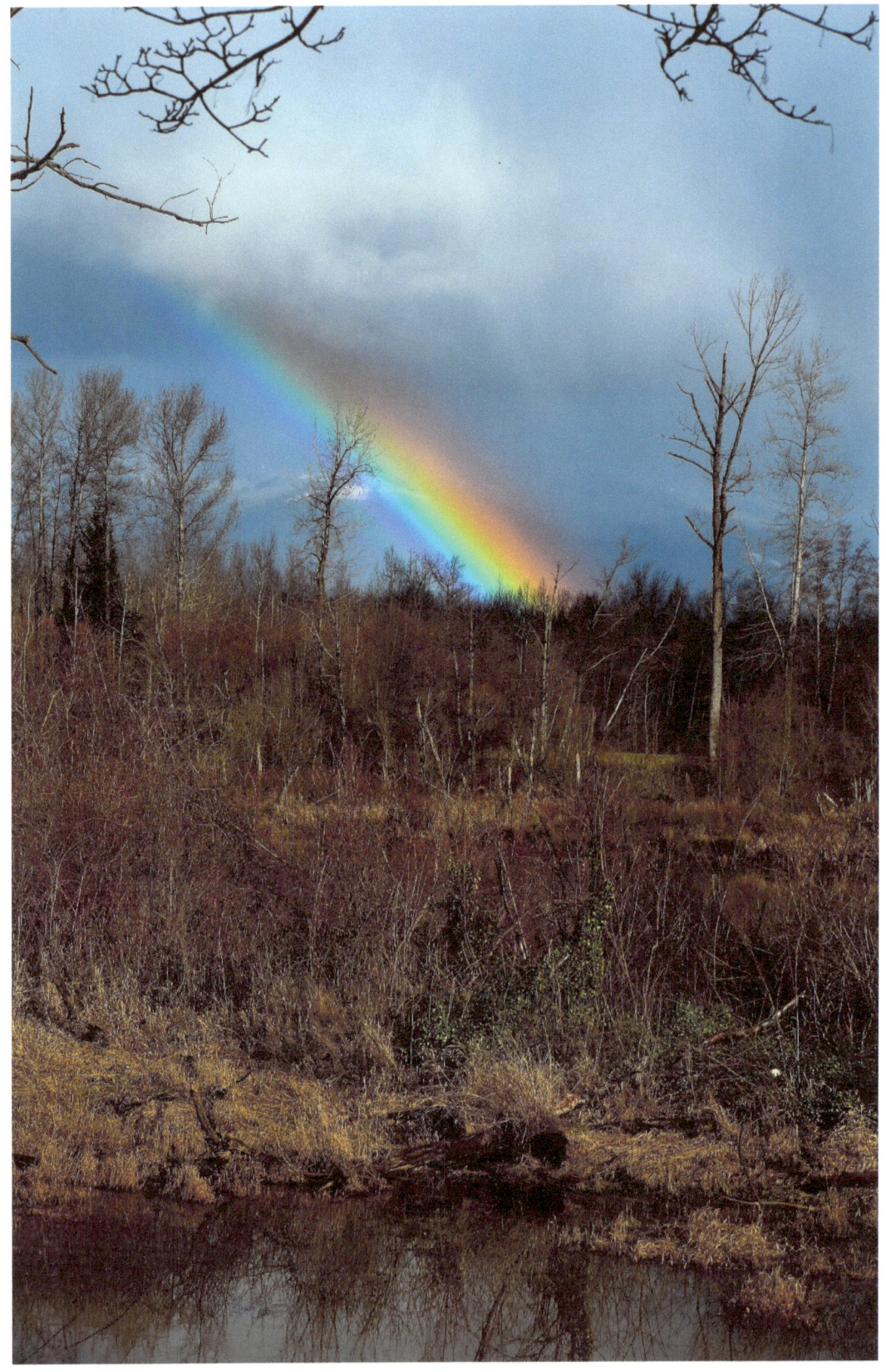

The sun is below the horizon here (above), casting a sun pillar up into the clouds.

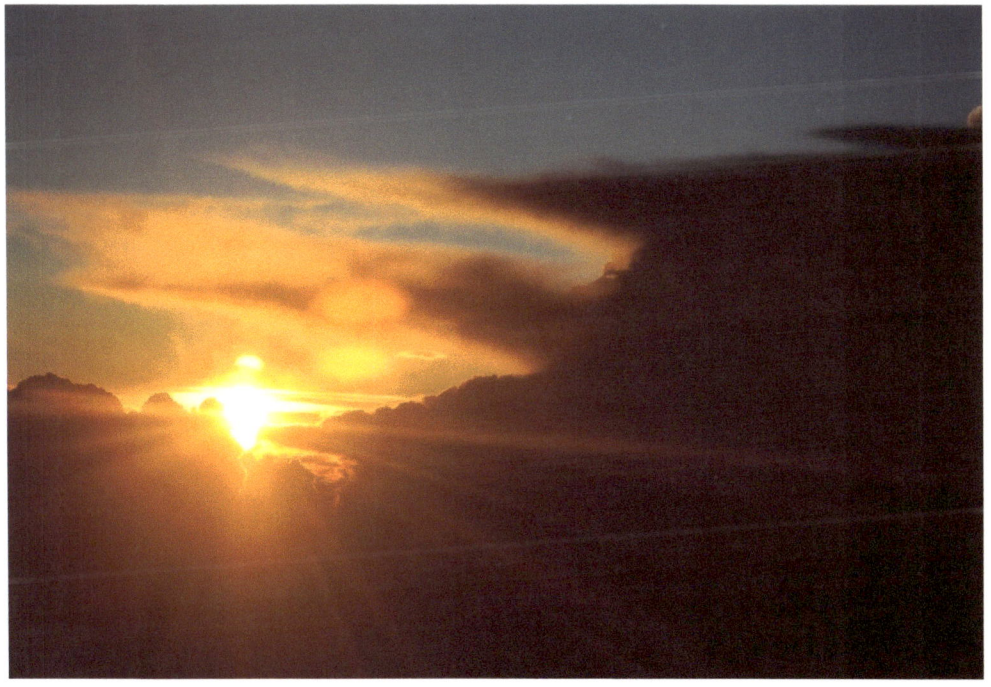

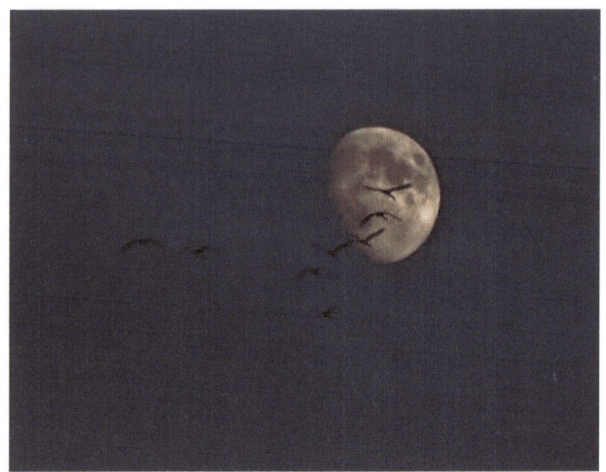

"When I admire the wonders of a sunset or the beauty of the **moon**, my soul expands in the worship of the creator." – Mahatma Gandhi

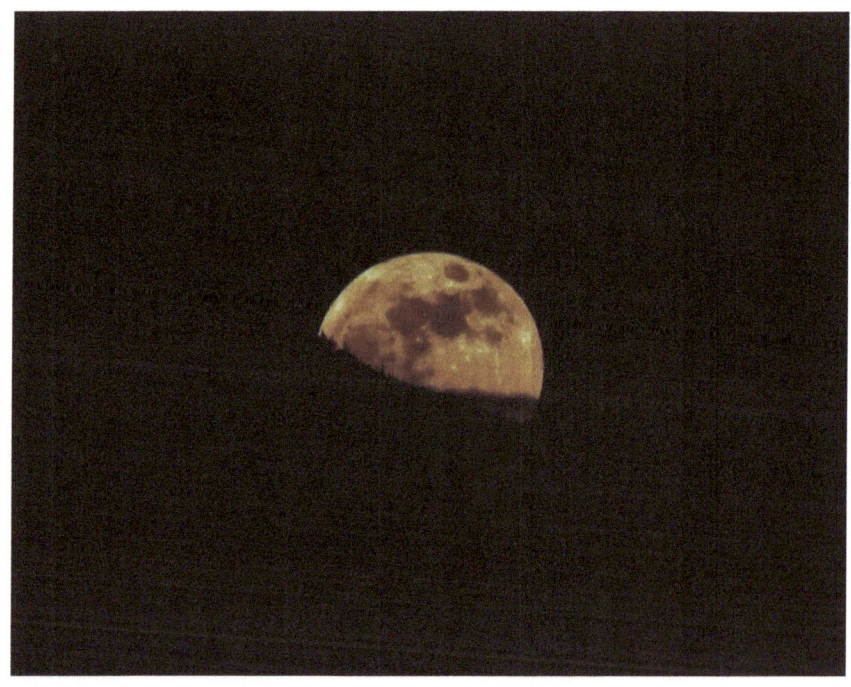

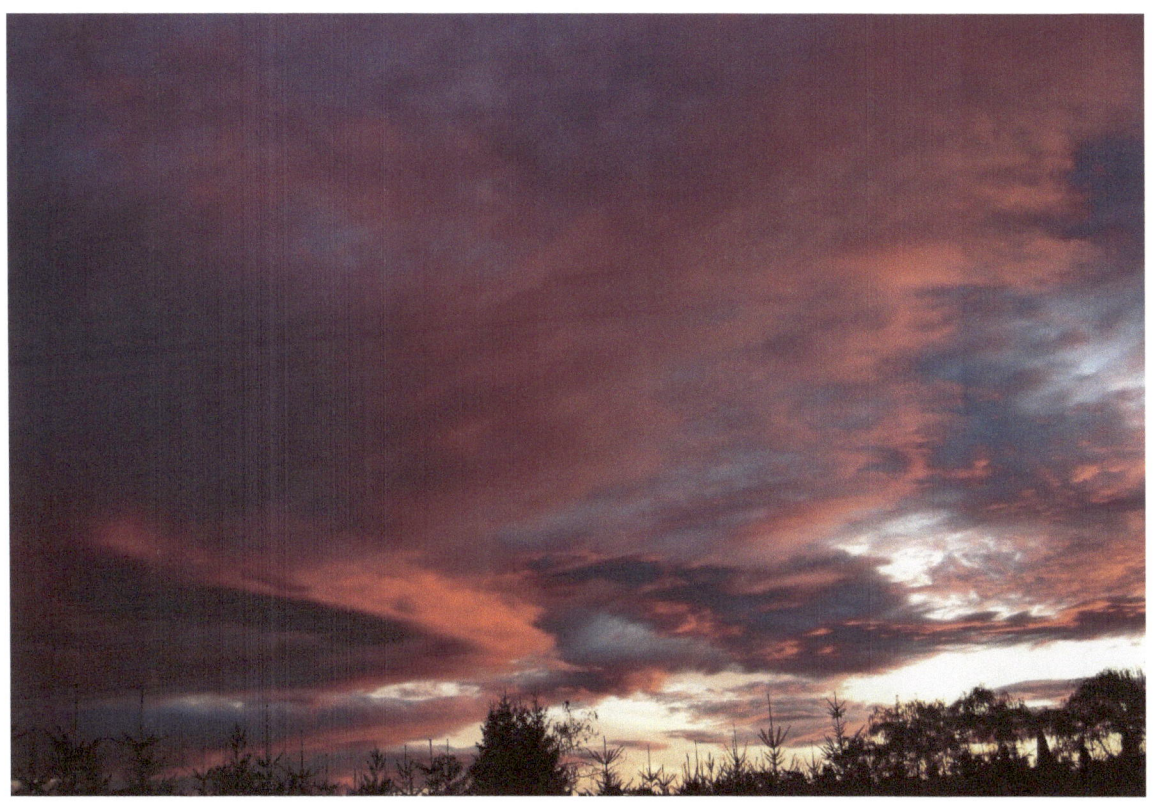
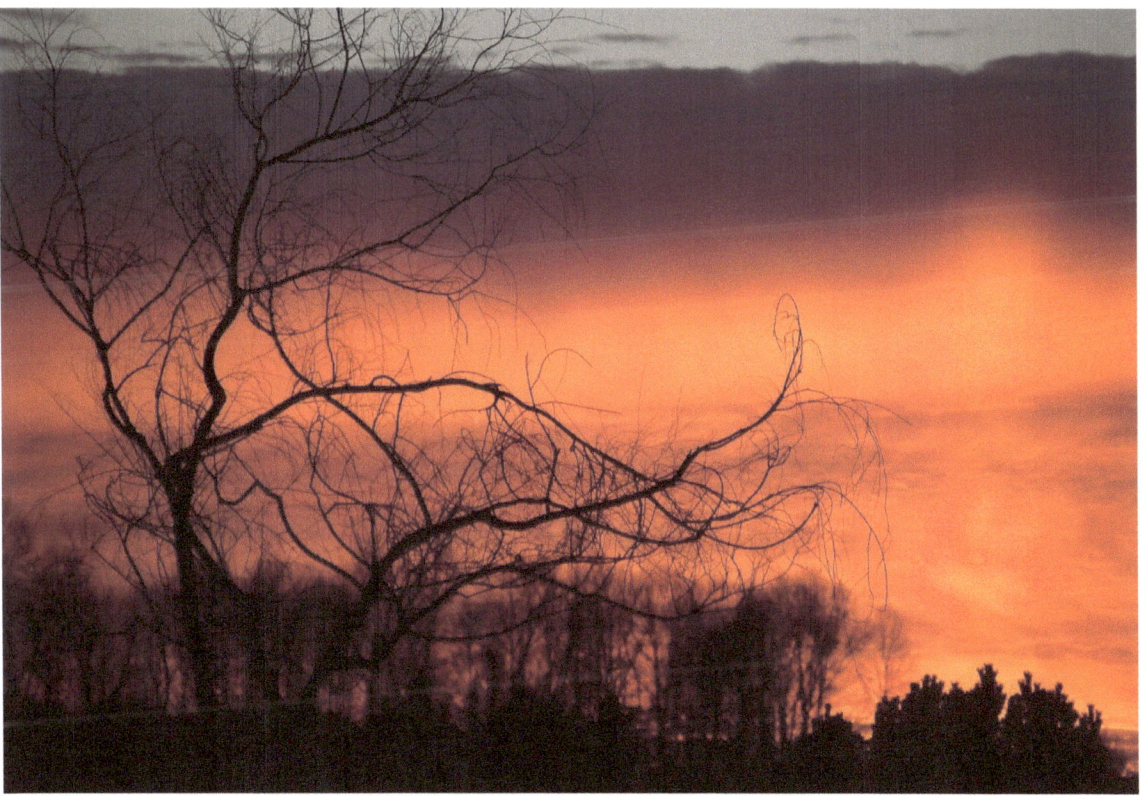

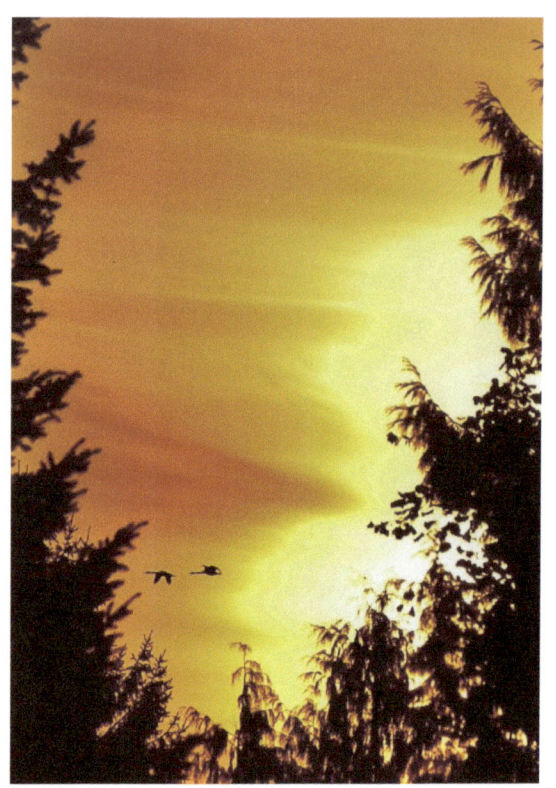
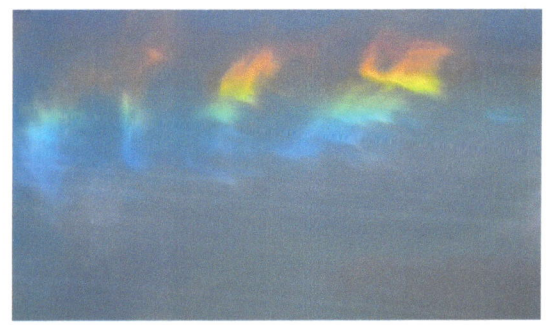
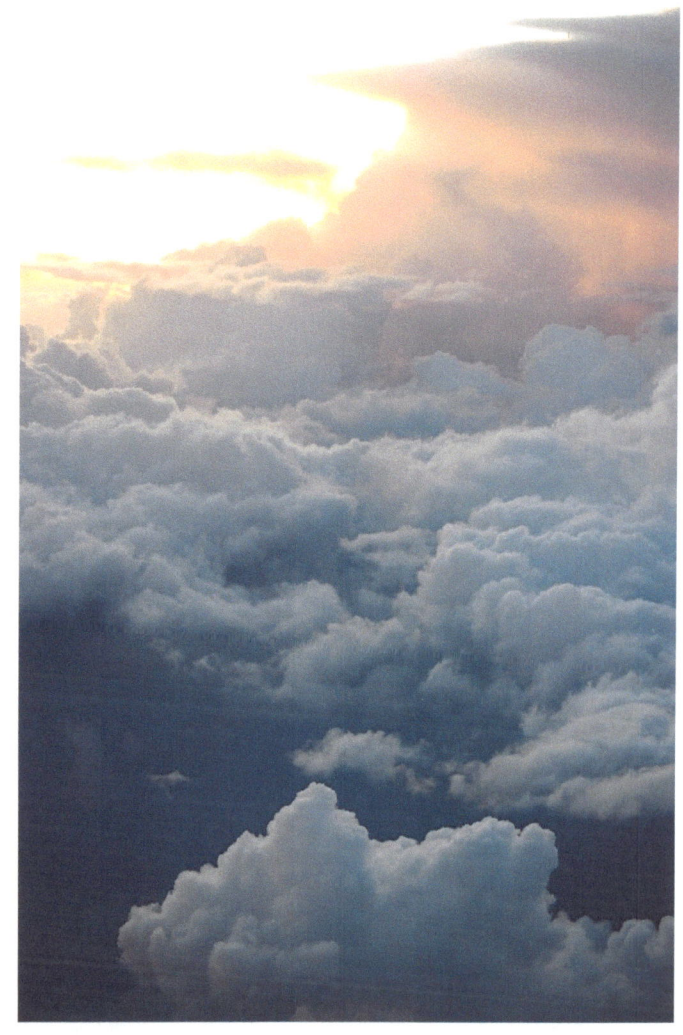

Inspirational

"Change your thoughts and you change your world"
-Norman Vincent Peale

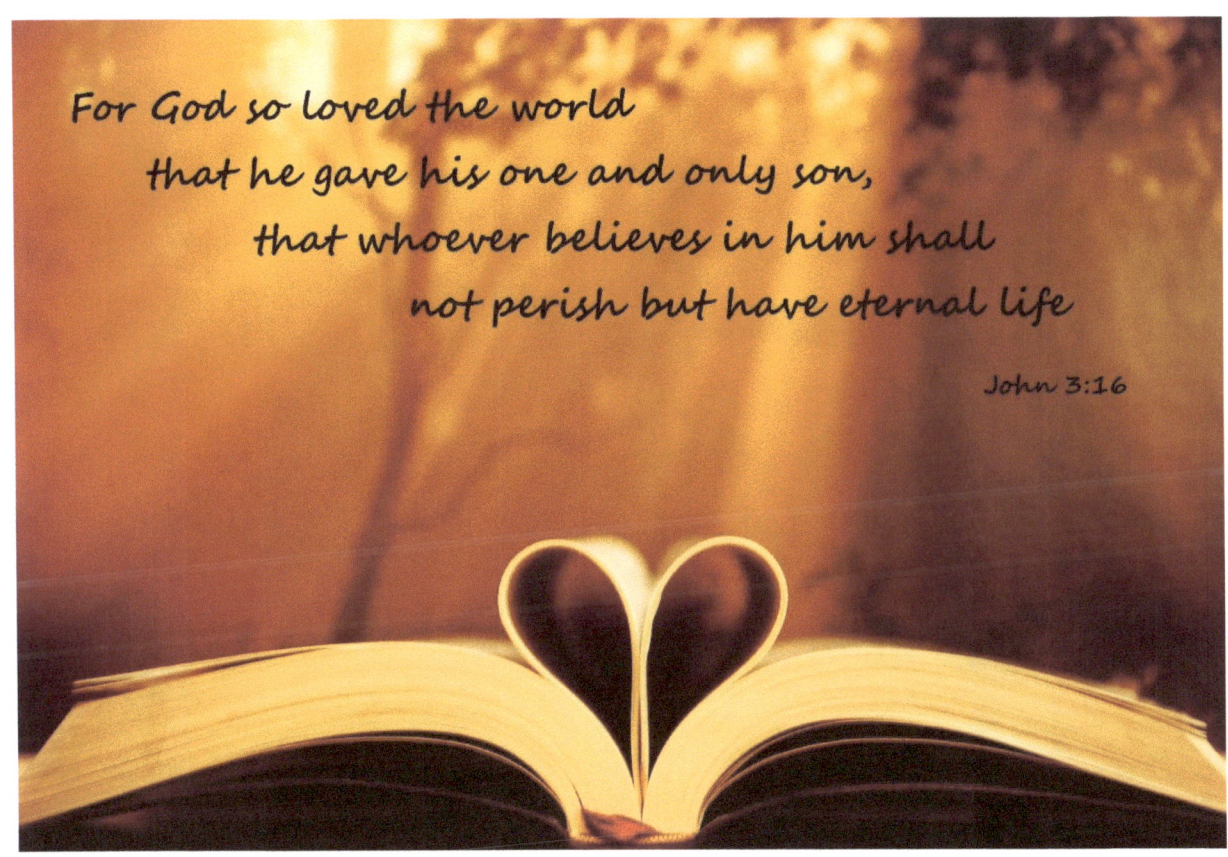

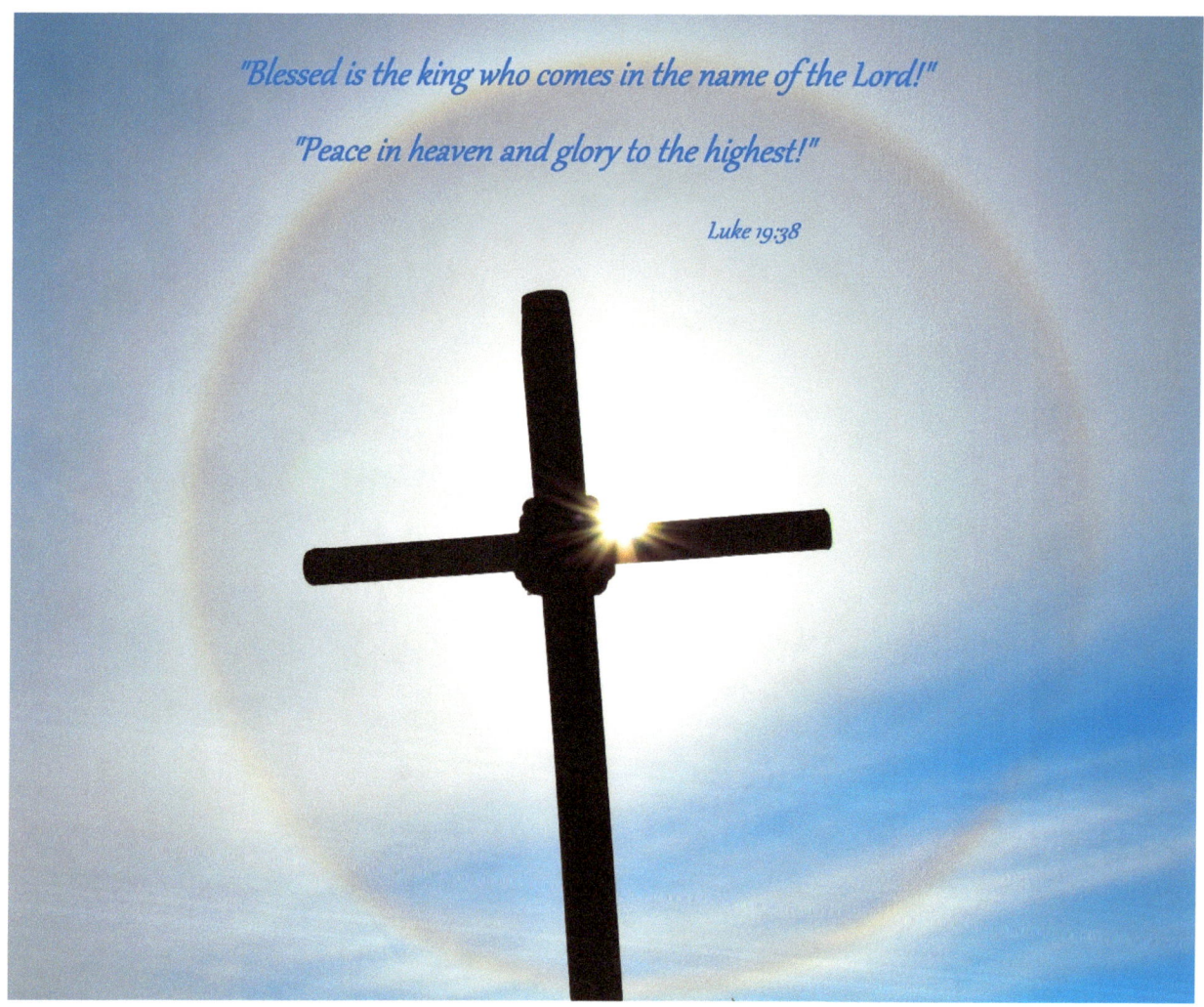

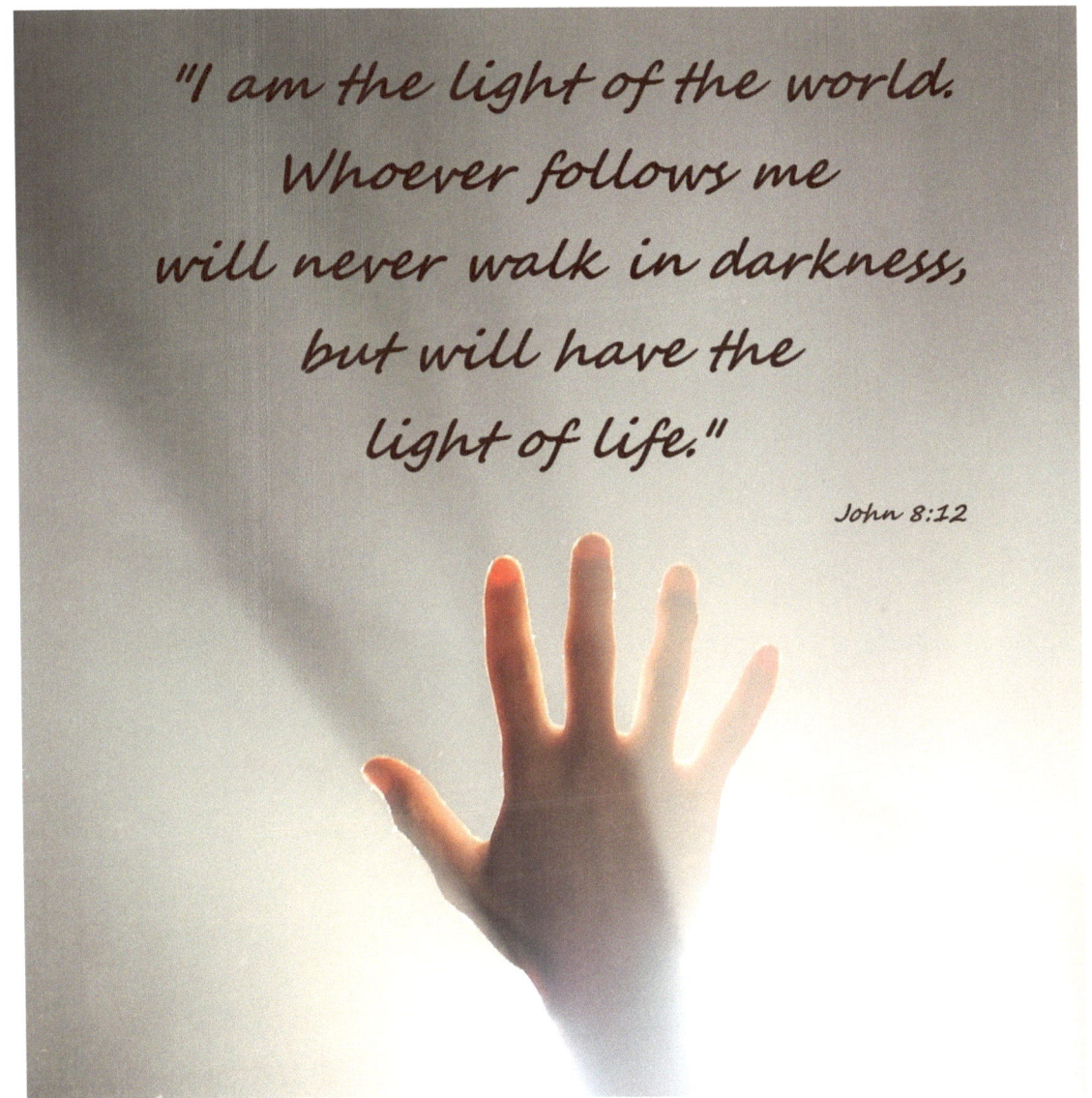

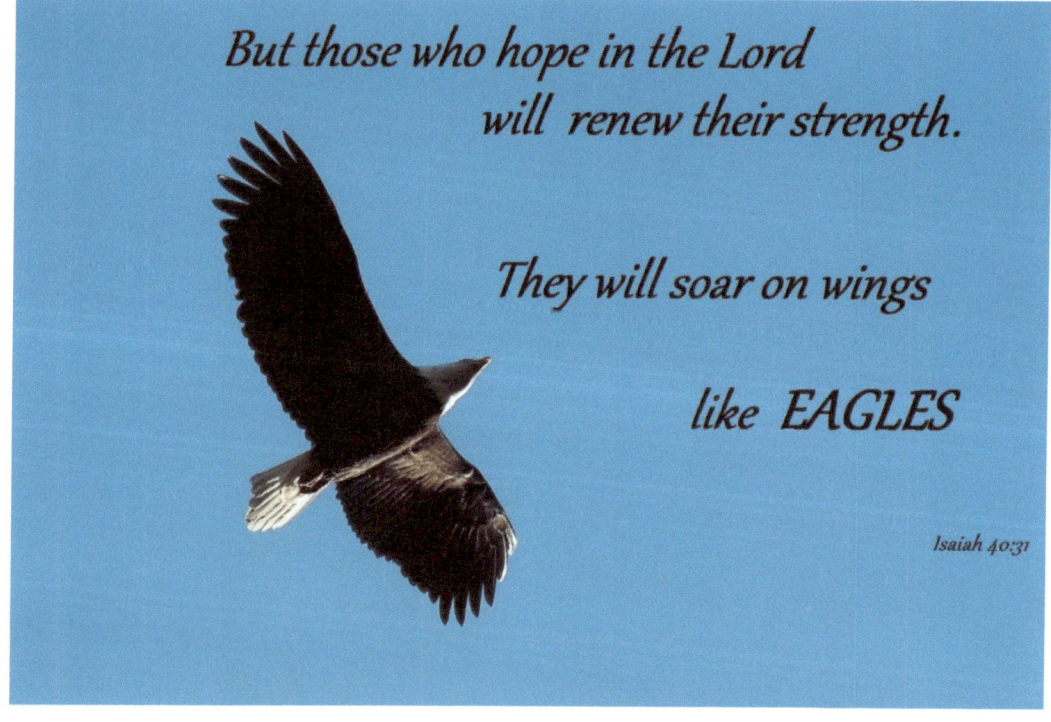

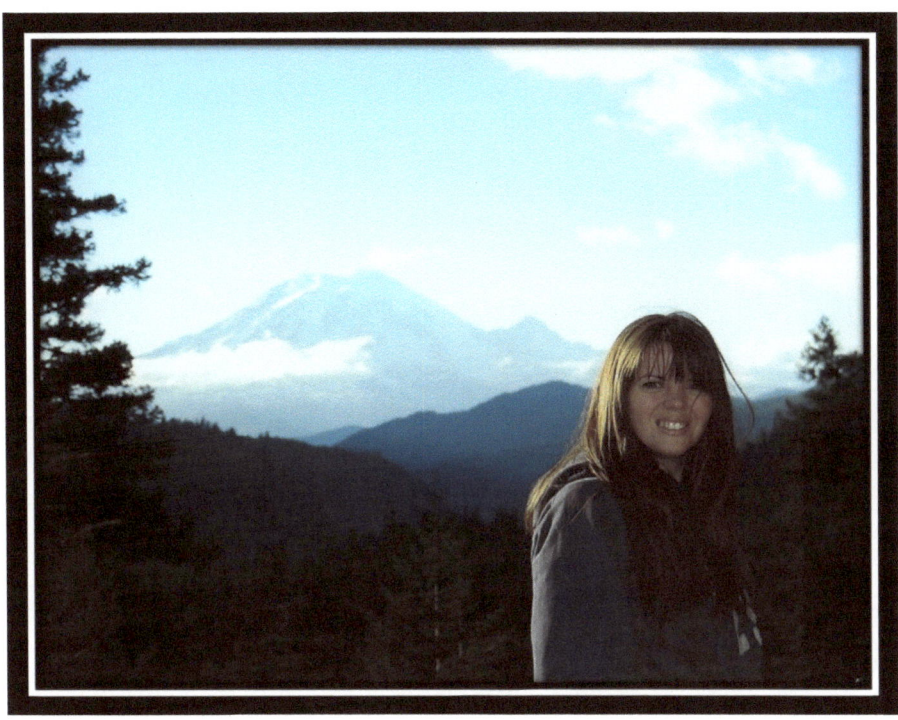

Author Tara Ellis lives in a small town in beautiful Washington State, in the Pacific Northwest. She enjoys the quiet lifestyle with her husband, two teenage kids, and several dogs. Having been a firefighter/EMT, and working in the medical field for many years, she now teaches CPR and concentrates on family, photography, and writing young adult novels.

www.ingramcontent.com/pod-product-compliance
Lightning Source LLC
Chambersburg PA
CBHW050853180526
45159CB00007B/2665